PRESERVE

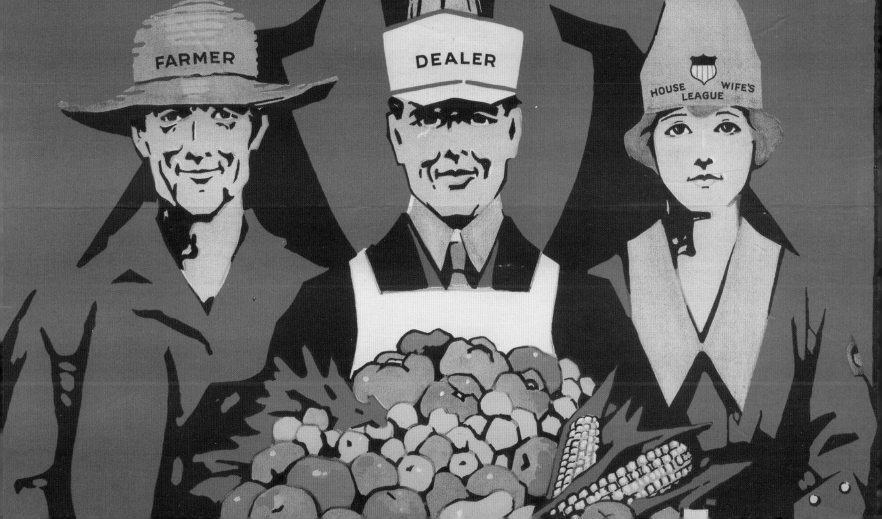

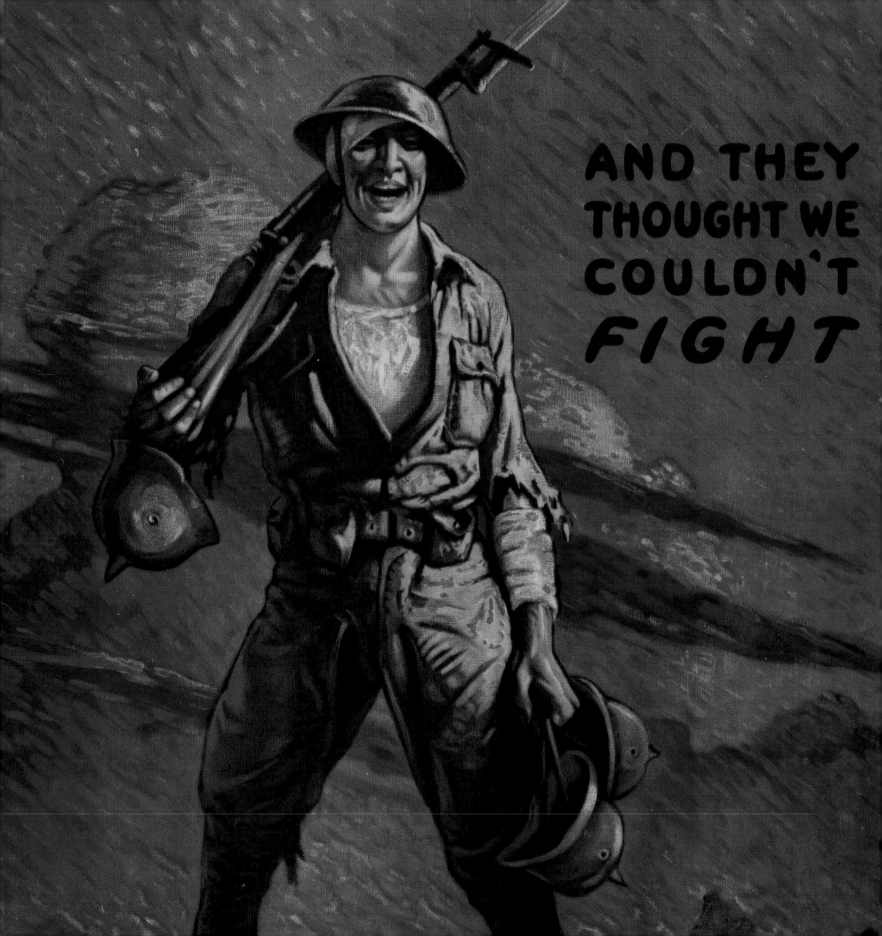

THE WINDS AND WORDS OF WAR

World War I Posters and Prints from the
San Antonio Public Library Collection

Edited by Allison Hays Lane

Trinity University Press
San Antonio, Texas

Exhibition Property of the San Antonio Public Library

SAN ANTONIO
PUBLIC **Library**
information. imagination. ideas.

2016–2018 Exhibition Tour Underwriting Sponsor

Bexar County Commissioners Court
Bexar County, Texas

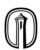

*Mission: to strengthen the library
in service to our community.*

SAN ANTONIO
PUBLIC LIBRARY
FOUNDATION

Book published by
Trinity University Press
San Antonio, Texas 78212

ISBN-13 978-1-59534-791-6 paper
ISBN-13 978-1-59534-792-3 ebook

Trinity University Press strives to produce its books
using methods and materials in an environmentally
sensitive manner. We favor working with manufac-
turers that practice sustainable management of all
natural resources, produce paper using recycled stock,
and manage forests with the best possible practices
for people, biodiversity, and sustainability. The press
is a member of the Green Press Initiative, a nonprofit
program dedicated to supporting publishers in their
efforts to reduce their impacts on endangered forests,
climate change, and forest-dependent communities.

The paper used in this publication meets the mini-
mum requirements of the American National Standard
for Information Sciences—Permanence of Paper for
Printed Library Materials, ANSI 39.48–1992.

CIP data on file at the Library of Congress
21 20 19 18 17 | 5 4 3 2 1

Edited by Allison Hays Lane and Rebecca Q. Cedillo
Designed by Zach Hooker
Typeset by Brynn Warriner
Photography by Seale Studios, San Antonio
Page 7 photography by Mendy Gonzalez Escamilla,
 Scarlet Photo Studios
Page 10 photography by Jason Risner
Color management by iocolor, Seattle
Produced by Lucia|Marquand, Seattle
 www.luciamarquand.com
Printed and bound in Hong Kong by Paramount
 Printing Company, Ltd.

Cover: *Books Wanted*, detail, see p. 44
Back cover: *Premiers au Feu Means in French First to Fight in
 English U.S. Marines*, see p. 51; *Britishers ENLIST
 TO-DAY*, see p. 46
Page 1: *Preserve Co-operation*, detail, see p. 52
Page 2: *And They Thought We Couldn't FIGHT*, detail,
 see p. 16
Page 5: *TELL THAT TO THE MARINES!*, detail, see p. 54
Page 6: *Wake Up, America!*, detail, see p. 14

2016 San Antonio, Texas Exhibition Venues

Campbell Memorial Library, Fort Sam Houston
The USAF Airmen Heritage Museum & Enlisted
 Character Development Center, Lackland Air
 Force Base
Bexar County Court House
Robert B. Green Clinical Pavilion, University Health
 System

2017–2018 European Exhibition Venues and Donors

Museum The Kennedys, Berlin, Germany, Courtesy
 Camera Works, Berlin, Germany
Justus-Liebig-Haus, Darmstadt, Germany, Courtesy
 City of Darmstadt, Germany
Wiltshire Museum, Devizes, United Kingdom
The Franco-American Museum, Château de
 Blérancourt, France
Musée de la Grande Guerre, Pays de Meaux

2008–2012 Founding Exhibition Tour

National Endowment for the Arts, Washington,
 D.C.
The Tobin Endowment, San Antonio, Texas
Stumberg Foundation, San Antonio, Texas
City of San Antonio, Veterans Affairs Commission

Contributors

Allison Hays Lane, Curator
Jeanne Campbell Reesman, Ph.D., University of
 Texas San Antonio
Char Miller, Ph.D., Pomona College, Claremont,
 California

San Antonio Public Library Representatives

Ramiro S. Salazar, Director
Paul Stahl, Chairman

*2016 San Antonio Public Library Foundation Executive
 Committee Officers*

Shannon Murphy Sachanowicz, *Chairman of the Board*
Jordan Vexler, *Vice Chair*
Hanna Sheesley Rochelle, *Secretary*
Paul Martin, *Treasurer*
Jill Giles, *Immediate Past Chairman*

National Exhibition Committee

Bexar County Judge Nelson W. Wolff
Commissioner Sergio "Chico" Rodriguez, Precinct 1
Commissioner Paul Elizondo, Precinct 2
Commissioner Kevin Wolff, Precinct 3
Commissioner Tommy Calvert, Precinct 4
Ramiro Salazar, SA Public Library, Director; Tracey
Ramsey Bennett, SA Public Library Foundation,
President; Lacey Fischer, SA Public Library
Foundation, Development Director; Allison Hays
Lane, Curator & Exhibition Program Manager;
Angelika Jansen Brown, Ph.D., Germany Exhibitions
Coordinator; James R. Adams, Chairman, Board of
Managers, University Health System; George B.
Hernández, Jr., President and CEO, University
Health System; Betty Bueché, Bexar County Heritage
& Parks Department, Director; Gilbert Candia,
Bexar County Heritage & Parks Department,
Curator; Rebecca Q. Cedillo, Project Liaison;
Frank Faulkner, Former SA Public Library, Texana
Librarian; Sujiro Seam, Consulat Général de France
à Houston; Damien Watel, Consul Honoraire à San
Antonio; General Alfred "Freddie" Valenzuela,
US WWI Centennial Commission; Libby H.
O'Connell, Ph.D., US WWI Centennial
Commission; Monique B. Seefried, Ph.D., US WWI
Centennial Commission; Michael D. Visconage,
Colonel, USMCR (Ret), Texas World War I
Centennial Commemoration; Jordan Vexler, SA
Public Library Foundation, Chair; James Lifshutz, SA
Public Library Foundation, Executive Comm.; Kaye
Lenox, SA Public Library Foundation, Past President;
Jennifer Robertson, JBSA Supervisory Librarian, Fort
Sam Houston; Rudy Purificato and Fernando Cortez,
Airmen's Heritage Museum, Lackland Air Force Base;
Bruce Bugg, Tobin Endowment; Tom Payton, Trinity
University Press; Laura Cole, Bibliotech, Director;
Jeanne Campbell Reesman, Ph.D., University of
Texas, San Antonio; Char Miller, Ph.D., Pomona
College, Claremont, CA; Karen Glenney, Ph.D.,
Director, Corporate Records Library, University
Health System; Lydia and Jean Pierre Lair; William
A. Phillips, Senior Vice President/Chief Information
Officer, University Health System; Sergio Farrell,
Senior Vice President, University Health System

TELL THAT TO THE MARINES!

AT 22 MONROE STREET

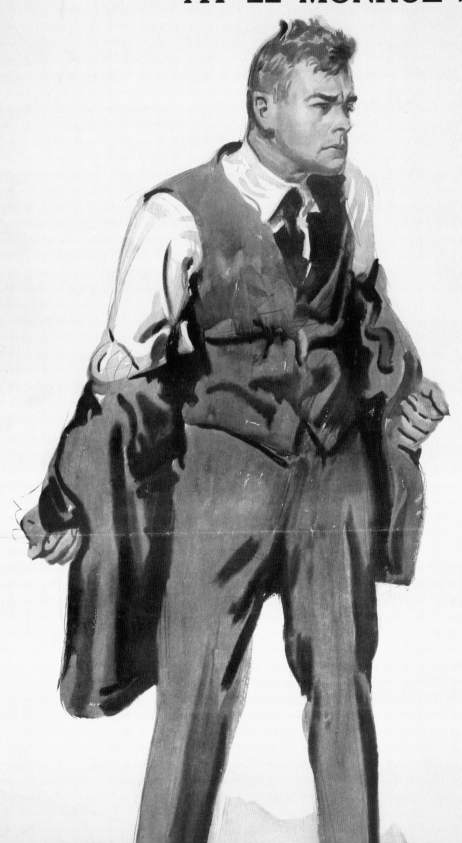

CONTENTS

PREFACE

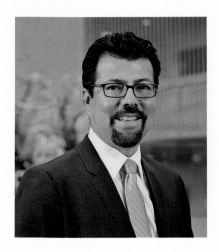

We are proud to be able to present a glimpse of the treasures housed in the vault of the Texana Collection of the San Antonio Public Library.

The World War I posters highlighted in this exhibit illustrate the depth of the Library's Texana Collection and the diversity of San Antonio's history—and reflect the painstaking care that has built the Texana Collection over nearly a century.

The Texana Collection was created in 1916 when the San Antonio Public Library acquired the private library of Henry McWhenney, a local traveling salesman. His library consisted of 528 books and pamphlets related to San Antonio and Texas. Today's Texana Collection, located on the sixth floor of the San Antonio Central Library, has grown to an estimated 100,000 items related to the history of San Antonio and Texas. This special collection possesses a wide assortment of rare and valuable historical materials.

The World War I posters, a gift to the library from Harry Hertzberg, have not been on public display since November of 1933. This new exhibition, with its educational, online, and artistic components, is the first in what we hope will be a future of unparalleled access to the unique holdings of the vault of the Texana Collection. The hard work that has gone into this project demonstrates the commitment of the San Antonio Public Library Foundation to support the San Antonio Public Library's effort to preserve and present items from the Texana Collection to a wider audience.

I would like to express my deep gratitude to the San Antonio Public Library Foundation and the Bexar County Commissioners Court for their sponsorship and support, and for making it possible to share these important and outstanding artifacts of American history with the public wherever this exhibit travels.

Ramiro S. Salazar
Library Director

INTRODUCTION & ACKNOWLEDGMENTS

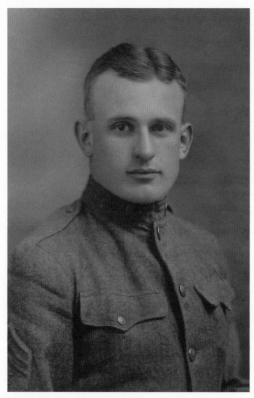

Sergeant First Class Paul S Hays, 1917

Gelatin silver print
Courtesy of Joseph Andrew Hays

To all the world he was a soldier, to me he was all the world.
—Rudyard Kipling writing about the death of his
son, Jack, age eighteen years and one day, upon
Britain's entrance into the Great War

The first major national marketing campaign in 20th-century America came not in the form of branding a product or selling a service but in the moving of an entire country, at a rapid pace, into the arena of a world war through the use of printed images. For the first time in history, the U.S. government employed leading illustrators, cartoonists, and painters to motivate the nation to abandon a position of isolationism and join forces with our European allies against German aggression and tyranny. While the political argument for going to war was being conveyed with an overpowering sense of urgency, these uplifting and emotional images provided a sharp contrast—showing the reality of the war.

The vehicle of choice was romanticized banner and lithographic images portraying Lady Liberty, Uncle Sam, and home and hearth, which helped inspire hundreds of thousands to give and serve. The unifying aspect of this national marketing campaign was that these images became the great equalizing force in American culture. People of all backgrounds and classes, rural or urban, educated or uneducated, rallied to the cause.

Many who had never been outside their county, much less their country, were trained and quickly shipped overseas to Europe to face the horrors of brutal modern warfare. My paternal grandfather, Paul S Hays, was one such person. Hailing from a small farming community in southern Indiana, he became a Sergeant First Class in the United States Army Ambulance Corps (USAAC), section 555. This unit served with the Italian Army under General Amando Diaz in the successful Piave River offensive in the Veneto region against Austro-Hungarian forces. Sgt. Hays was awarded the *Crocca al merito di guerra* for his willingness to evacuate stricken soldiers and civilians with influenza.

It has been a pleasure to make that reconnection with my own family history, and I sincerely hope that communities around the

world will solicit oral histories, open trunks in the attic, and discover the power of personal histories and how they relate to current events. Through the blending of art and history, we have been able to peel back the layers of time to reveal a commonality between this outstanding collection and an awareness of its implications today.

With sincere gratitude I acknowledge the generosity of those who provided the original funding to make the 2008–2012 national tour a reality. Thanks to the support of the City of San Antonio Veteran's Affairs Commission; Mr. and Mrs. Louis Stumberg and the Stumberg Foundation, San Antonio; Mr. Bruce Bugg and The Tobin Endowment, San Antonio; and the National Endowment for the Arts, Washington, D.C., the exhibition and catalog reached more than 150,000 people.

I am grateful to San Antonio Public Library Director Ramiro Salazar for his leadership in the long evolution of this project and for allowing us to share this material with an international audience. Additional thanks to the staff of the San Antonio Public Library Foundation (SAPLF): Tracey Ramsey Bennett, President; Lacey Fischer, Director of Development; staff members Carol Black and Loni Dear, for their dedicated support since the conception of the project and "being in the trenches with me" throughout the national and international tours of the exhibition.

Our ability to honor the rich and vibrant history of World War I in San Antonio with this collection was funded by a three-year grant from the Bexar County Commissioners Court: Judge Nelson W. Wolff, Commissioner Paul Elizondo and Commissioner Kevin Wolff—veterans themselves—and Commissioners Sergio "Chico" Rodriguez and Tommy Calvert. This generous support has enabled us to share the material with more than 50,000 residents of Bexar County through the venues of Fort Sam Houston, Lackland Air Force Base, Bexar County Courthouse, and the Robert B. Green Clinical Pavilion. The multi-year grant also enables travel to educational venues throughout Europe and the United Kingdom from 2017-2018 to honor the end of the Great War.

I offer deep gratitude to Rebecca Quintanilla Cedillo, President, Strategic Planning Initiatives Consulting, for her amazing guidance and crucial support launching our international tour. Special thanks to Dr. Angelika Jansen Brown for her expertise coordinating our venues in Germany. I am very appreciative of the encouragement of the following people who have provided support for this project over the last years: James Lifshutz; Josh Campbell; Karen F. Glenney, Ph.D., and Robert Grothues; Ansen Seale; the San Antonio Public Library and Foundation boards; the United States WWI Centennial Commissioners—especially General Alfred Valenzuela, USA (Ret) and Monique Seegfried; the San Antonio National Exhibit Committee; Aubrey Smith Carter; Betty Bueché and Gilbert Candia; and Sujiro Seam, Consular General of France, (Houston). We are honored to have such distinguished donor venues as: Museum The Kennedys, Berlin, Germany, Courtesy of Camera Works, Justus-Liebig-Haus, Darmstadt, Germany, Wiltshire Museum, United Kingdom, The Franco-American Museum, Château de Blérancourt, France, and Musée de la Grande Guerre, Pays de Meaux. I am very appreciative to their boards and staffs for their professional support and hospitality.

Special recognition and appreciation are due Kaye Lenox and Frank Faulkner, who originally saw, in 2006, the inherent importance of this acquisition from the Harry Hertzberg Collection as it joined the Special Collections of the San Antonio Public Library, and urged that it be offered to a broader audience.

Special thanks also are due to Dr. Jeanne Campbell Reesman, Professor of English, University of Texas, San Antonio; and Dr. Char Miller, Professor of History and Urban Studies, Pomona College, Claremont, California—for their insightful essays and support. Thank you to Lucia|Marquand and Trinity University Press. It was an honor and pleasure to work with them.

In closing, a heartfelt thanks to my family, especially my children, Anna, Shelby, and Andrew, for their patience during the years of seeing this project through to completion. A writer would be lost without the assistance of a superb editor, so many thanks to my mother and author, Anna Jane Hays. Having had the great fortune to be in a home where reading, as well as a love of history and art, was treasured, my gratitude to my father, Andy Hays, who painstakingly researched our family history relating to WWI.

The years 1917–1918 reveal San Antonio and Bexar County as being instrumental to the successful outcome of the war effort. Hundreds of thousands of soldiers and pilots were trained and outfitted at Fort Sam Houston and throughout camps across the city and county before deployment to the Western Front. The growth of the nascent United States Air Force began at Kelly and Brooks Fields. Today, San Antonio proudly bears the name, *Military City, USA*, based on this history. It is with great pleasure that I dedicate this project to the memory and service of my grandfather and all those who bravely fought and gave the ultimate sacrifice in World War I.

Allison Hays Lane
October 16, 2016

Bexar County Commissioners Court—Sergio "Chico" Rodriguez,
Precinct 1; Paul Elizondo, Precinct 2; Judge Nelson W. Wolff;
Tommy Calvert, Precinct 4; Kevin Wolff, Precinct 3.

FOREWORD

Esteemed Readers,

The Winds and Words of War is a living testament to the spirit and valor of a nation engaged for the first time in global conflict. It is with great pride on behalf of the Bexar County Commissioners Court that we offer this exhibit for its European tour. As sponsors, the 40 original WWI lithographs will be shown in Germany, the United Kingdom, Belgium, and France.

During this two-year tour, the posters will be accompanied by didactic prints portraying San Antonio's participation in the military, industrial, and civic sectors. San Antonio's Kelly and Brooks Fields are the birthplace of the nation's modern Air Force—training pilots and maintenance of the air fleet. Zeppelin maneuvers were carried out in Olmos Basin through Camp Stanley. Additionally, General Pershing's horse soldiers and other cavalry units trained in San Antonio—a tribute to Teddy Roosevelt's Rough Riders tradition—also a San Antonio legacy.

The exhibit has been certified by the United States WWI Centennial Commission and will make its way to Europe to commemorate the 100-year anniversary of America's entry as an ally and the Armistice signing on November 11, 1918.

As Americans, we are honored to sponsor this four country traveling program of art work that tell the story of patriotism, volunteer services and activities to sustain the national fervor for the duration of our nation's involvement. They are told in several languages, each with its own distinct, direct message.

As citizens and residents of Bexar County we are proud to also showcase our efforts in the Great War. We manufactured aircraft and were the maintenance depot for the fleet. Bexar County clothed, fed, trained, and hospitalized our soldiers and airmen. Our families also sent doughboys to fight thousands of miles from home.

We are proud and honored to bring our stories of 100 years ago to the nations we helped defend. This opportunity to sponsor the exhibit is a way to honor our community's legacy and tradition of service.

Sincerely,

Nelson W. Wolff
Bexar County Judge
Bexar County Commissioners Court

BATTLE-READY CITY
SAN ANTONIO IN THE GREAT WAR

Char Miller, Ph.D.
Trinity University, San Antonio, Texas
Pomona College, Claremont, California

"Beat Back the Hun with Liberty Bonds" — illustrator Frederick Strothmann's contribution to a World War I fundraising scheme, is full of menace and dread. Against a smoke-filled and yellow-stained sky, a German soldier looms above a ruined Belgian town, its battered remains a reflection of an unconditionally lethal onslaught; the soldier's bayonet, which thrusts across the page on the diagonal, drips with bright-red blood; so too his fingers. That terrorizing image, set in sharp contrast to his dull gray uniform and helmet, and an equally blank-gray face, is magnified when you realize that this murderous figure gazes straight at you, a cold gleam emanating from his slate-green eyes.

It gave me chills the first time I saw Strothmann's poster, a gift from my father who had received it from his father. Its real value, however, lies not in this genealogical lineage but in its unnerving capacity to jolt: every year I am reminded of its still-potent force when partway through a lecture on the critical role of propaganda in shaping American responses to the Great War, I pick up the poster and carry it around my classroom so that my students can see what I am trying to capture in mere words. They recoil as if hammered by the kick of a Springfield rifle — standard issue to the American Expeditionary Forces in Europe.

Stunned by its continuing capacity to evoke fear, and disturbed by its dehumanizing brutality, students come away with a better sense of some of the impulses that framed and haunted that earlier generation's declaration of war. They are likewise startled to learn just how important San Antonio and South Texas were to the formulation of the war effort. Although thousands of miles away from the ghastly trenches in eastern France, buffered by the Atlantic Ocean and much of the North American continent, and therefore immune to the vicissitudes of a devastating conflict that claimed upwards of 20 million lives, the Alamo City and its hinterland helped place the nation on an aggressive wartime footing.

This claim about San Antonio's manifold contributions to the U.S. decision to join arms with the Triple Entente (Britain, France, and Russia) in its fight against the Central Powers (Germany, the Austro-Hungarian Empire, and Italy) is rarely made in analyses of the tumultuous geopolitical situation that let loose the guns of August 1914. Understandably so: far more compelling is the focus on the late June 1914 assassination of Archduke Franz Ferdinand, heir to the Austrian imperial throne, which triggered a series of linked declarations of war between European nations great and small; two months later the continent was caught in a brutal, protracted struggle of its own making.

The official American response was to remain neutral, a strategy that President Woodrow Wilson affirmed over the next two and a half years. Although his position dovetailed with public opinion, it also became increasingly difficult to maintain as the German and British navies sought to use their competitive advantages — submarines and ships, respectively — to destroy the other's capacity to fight. In the middle of this intensifying battle was the American merchant fleet. As it plied the North Atlantic, carrying food, fuel, and weapons to the belligerents, the vast bulk of which ended up in French or British ports, the Germans began to target this vital supply line; their torpedoes began to take a toll on the flow of cargo.

Yet it was German attacks on passenger liners (notably the 1915 sinking of the SS *Lusitania* which killed 1,198, including 128 from the United States) that by early 1917 intensified American sympathies for the Triple Entente's cause. With pressure mounting, on April 2 the president called Congress into "extraordinary session because there are serious, very serious, choices of policy to be made, and made immediately, which it was neither right nor constitutionally permissible that I should assume the responsibility of making."

In his request, Wilson, the former president of Princeton University, laid out a carefully reasoned legal brief: because the German use of submarines violated international law; because their destructive force was aimed at the "wanton and wholesale destruction of the lives of non-combatants . . . engaged in pursuits which have always, even in the darkest periods of modern history, been deemed innocent and legitimate," it was manifestly clear that neutrality "is no longer feasible or desirable." Under these conditions, armed confrontation was the only answer: "the world must be made safe for democracy."

Wilson's words hit home in San Antonio. As one of the city's dailies, the *Light*, observed: "The war between the United States

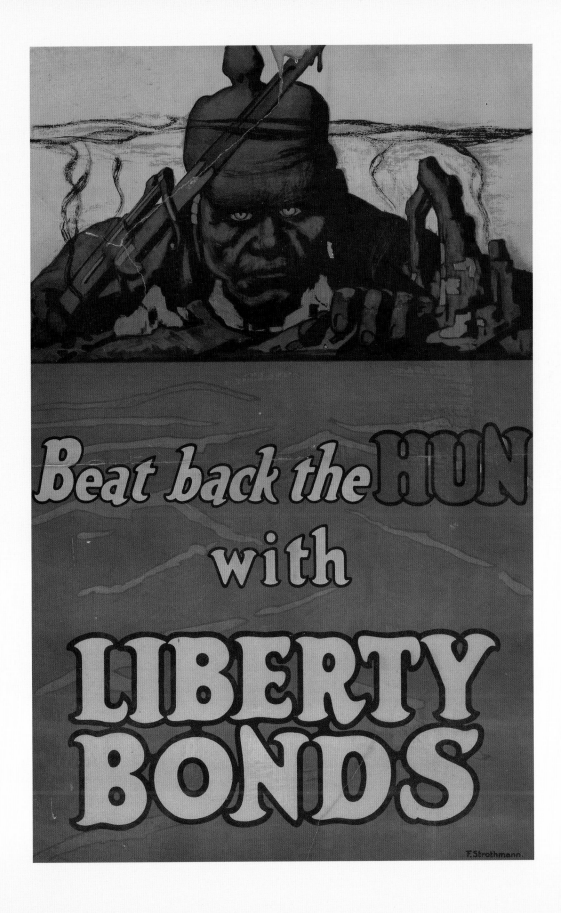

Frederick Strothmann
Beat back the HUN with LIBERTY BONDS

Lithograph
29 × 20 inches
Courtesy of Char Miller

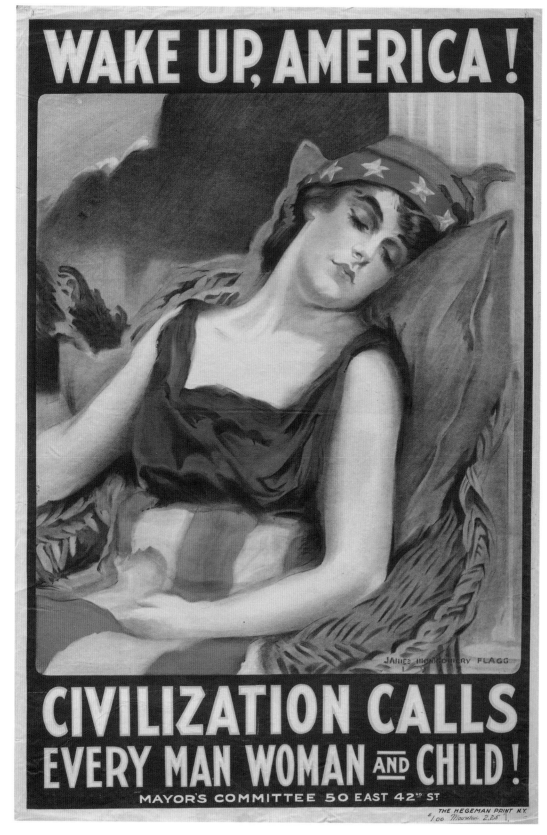

James Montgomery Flagg
Wake Up, America!
Lithograph
41 × 28 inches
Collection of the San Antonio
Public Library

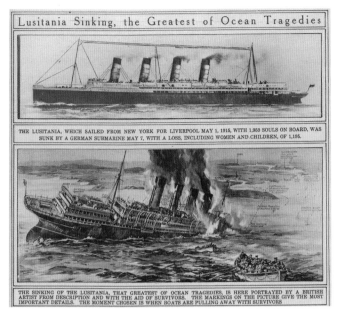

Lusitania Sinking, the Greatest of Ocean Tragedies

THE LUSITANIA, WHICH SAILED FROM NEW YORK FOR LIVERPOOL MAY 1, 1915, WITH 1,959 SOULS ON BOARD, WAS SUNK BY A GERMAN SUBMARINE MAY 7, WITH A LOSS, INCLUDING WOMEN AND CHILDREN, OF 1,195.

THE SINKING OF THE LUSITANIA, THAT GREATEST OF OCEAN TRAGEDIES, IS HERE PORTRAYED BY A BRITISH ARTIST FROM DESCRIPTION AND WITH THE AID OF SURVIVORS. THE MARKINGS ON THE PICTURE GIVE THE MOST IMPORTANT DETAILS. THE MOMENT CHOSEN IS WHEN BOATS ARE PULLING AWAY WITH SURVIVORS

Newspaper illustration of the SS *Lusitania*, *The War of Nations Portfolio*, Rotogravure etchings, Published in the *New York Times*

and Germany which all farsighted people have long beheld as a possibility, and which all right-minded people have conscientiously endeavored to avoid, has come." It came, the newspaper asserted, because "Our good intentions have been misconstrued, our patience has been abused, our forbearance has been outraged." It was left to Americans to "prove to the world that, although a peace-loving people, we are still the children of those who . . . have never failed . . . to finish in their own way those things to which they have set their hand."

The *Light*'s readers no doubt thrilled to these patriotic sentiments, for San Antonio long had been at the center of armed conflict. Late-seventeenth-century Spanish explorers and missionaries had established it as a fortified outpost on the northern frontier of New Spain; it had served the same function after Mexico overthrew its Spanish overlords, and held a similarly strategic position for the Texas Republic (1836–1845), and for the United States, which took possession of the region in the late 1840s. Thirty years later, with the establishment of Fort Sam Houston, which for a time would hold the distinction of being the nation's largest military base, the link between the city and the U.S. Army tightened. During the Spanish-American War of 1898, for instance, Fort Sam trained military units, with Teddy Roosevelt's Rough Riders bivouacking at nearby Camp Wood. Its capacity would expand with the creation of an American empire in the Caribbean. Between 1898 and 1917, the United States stationed troops in Puerto Rico, the Panama Canal Zone, and Cuba; established formal protectorates over Haiti, the Dominican Republic, and Panama; and periodically occupied each of these countries as well as Nicaragua, Honduras, and Mexico. A large contingent of these soldiers first earned their stripes in Fort Sam's classrooms, at its firing ranges, and on its parade grounds.

These overseas engagements proved formative in a larger sense: they were rigorous testing grounds for the American armed forces and their equipment in the run-up to World War I. Most immediate of these was the 1916 Mexican Expedition. Also known as the Punitive Expedition and commanded by General John "Blackjack" Pershing, then headquartered at Fort Sam Houston, this strike force was sent to the U.S.–Mexico border to prevent Mexican guerillas from attacking across the Rio Grande; most famously, it punched deep into northern Mexico in a futile attempt to capture revolutionary Pancho Villa, whose troops had raided Columbus, New Mexico, in early March 1916. More than 150,000 members of the National Guard had been called up as part of the action, a goodly number of whom were shipped to San Antonio to

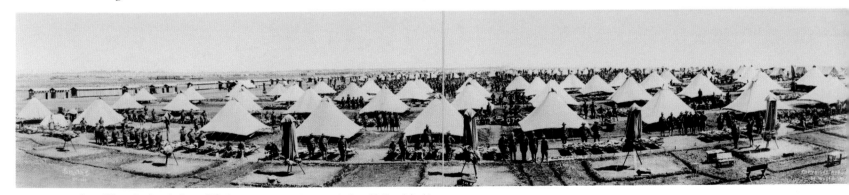

Harry Budrow, **Camp Wilson, San Antonio, Texas, 1916,** Gelatin silver print, 7 × 29 inches, National Archives

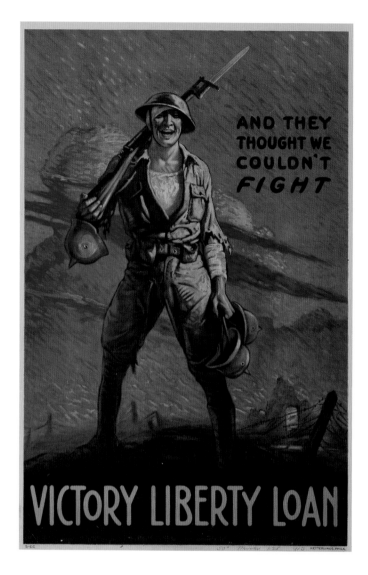

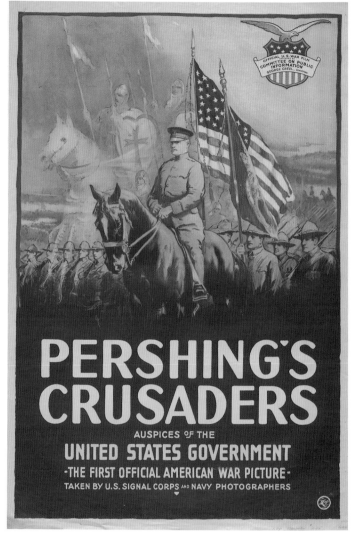

And They Thought We Couldn't *FIGHT*

Lithograph
41 × 27 inches
Collection of the San Antonio Public Library

Pershing's Crusaders

Lithograph
40 × 28 inches
Collection of the San Antonio Public Library

receive basic training at Camp Wilson, practice gunnery at Leon Springs Military Reservation, and learn tactical maneuvers at Camp Bullis. Although they failed to take Villa into custody, and were mustered out of federal service in late 1916, these newly hardened soldiers and officers had learned invaluable lessons that they would put to good use when they were re-mobilized only months later to sustain Congress' April 6, 1917, resolution: "Whereas the Imperial German Government has committed repeated acts of war against the Government and the people of the United States of America; Therefore be it Resolved . . . that the state of war between the United States and the Imperial German Government which has thus been thrust upon the United States is hereby formally declared."

The long-awaited declaration, cheered across the country, was a boon to San Antonio. Its extensive history as a military service center and staging ground, a mission that the Army recently had expanded with the 1915 construction of its first aviation facility—Dodd Field—on the grounds of Fort Sam Houston, insured a remarkable influx of trainees for the duration of the war and a steady infusion of federal dollars into communal coffers.

Bases old and new dotted the local map. Camp Wilson was renamed Camp Travis and overnight became a self-functioning city replete with fourteen hundred temporary buildings built in three months and in which more than one hundred thousand soldiers—approximately 10 percent of all Americans who served in Europe during the war—were housed, fed, and taught.

Dodd Field could not accommodate the Army's escalating demands for flight-ready pilots and ground crew, so the Department of War leased 700 acres south of the city for Kelly Field and within a year added another 1,800 acres. This rapid expansion is understandable given its mind-boggling training schedule: on Christmas Day 1917 over 39,000 men were stationed at the field, and the next month, despite shipping out 15,000 cadets, another 47,774 recruits had arrived. Cumulatively, "Kelly soldiers organized approximately 250,000 men into aero squadrons during the hectic months of 1917 and 1918. The Enlisted Mechanics Training Department turned out an average of 2,000 mechanics and chauffeurs a month. Most of the American-trained World War I aviators learned to fly at this field, with 1,459 pilots and 398 flying instructors graduating from Kelly schools during the course of the war." Among these was a local boy made good: Edgar Tobin, a member of Capt. Eddie Rickenbacker's "Hat in the Ring" air squadron and a highly decorated ace.

Kelly's boom was such that yet another airbase, Gosport (later Brooks) Field, had to be carved out of the city's southside; on its 1,300 acres, pilots were trained to fly balloons and airships.

Civilians pitched in as well: Marjorie Stinson, who with her daredevil-pilot siblings, Katherine and Edgar, had trained fliers at Fort Sam before the war, continued doing so once hostilities began, operating out of Stinson Field, the city's municipal airport. Soldiers marched, planes whizzed overhead, rifle-fire crackled, and howitzers thundered: however far removed it was from the major battlefields at Verdun, Ypres, and the Somme, San Antonio must have sounded and smelled as if it was in the very midst of war.

Walking its downtown streets would have confirmed as much: uniforms were everywhere; military vehicles crisscrossed the city between its many bases, depots, and camps; and entrepreneurs eager to cash in on wartime spending were in abundance. Some visionaries hoped that the war would increase the city's industrial base; and what better item could it manufacture than airplanes? Their ambitions made sense but inept leadership, divisive politics, and the failure nationally for postwar aircraft production—military and civilian—to take off, scuttled the idea. Yet out of this civic activism emerged a greater emphasis on military spending in San Antonio's economy and thus a greater dependence on its appropriations. In times of conflict, the citizenry would discover, that could be beneficial; in peace, as federal funding dwindled so would their fortunes.

That said, the population grew: in 1910, 96,000 lived in the city, and at the close of the war it was home to more than 160,000. These figures do not factor in the waves of temporary residents who flooded into town for basic training or advanced instruction; few of them had ever weathered anything like the region's withering heat or sticky humidity, its furious thunderstorms or bone-chilling "blue

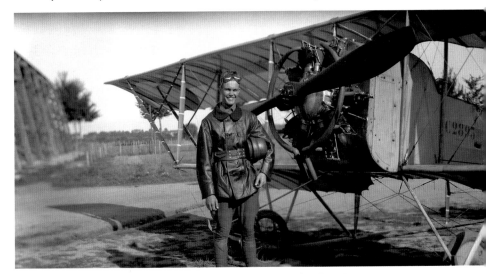

Edgar Tobin Gelatin silver print, courtesy of The Tobin Endowment, San Antonio

northers" that screamed down the plains. One pilot remembered "arriving at Kelly Field after withstanding a long, hard trip, when food had been given out 36 hours early, with great anticipation of becoming a great aviator and of making fame by bombing old Hun 'Bill's' palace," only to snap to attention when he found himself "lined up in front of a row of tents . . . feet in black mud and the wind blowing a gale, trying to obey the orders—'prepare for inspection.'"

No less bewildering were these newcomers' close encounters with San Antonio's notorious red-light district, a vast warren of bars, gambling emporia, and brothels located near the central business district. It reminded an aviation cadet of what he imagined a "roaring, wild west town" would look like; the city "seemed to abound in saloons that were decorated with extremely long cow horns on the walls, and with glass enclosed, realistically preserved habitants of the state, including coiled rattlesnakes and hairy tarantulas, to greet the visitor's startled eye from many nooks and crannies." This was an unusual place in a disorienting time.

Then suddenly hostilities ceased: the armistice was signed on November 11, 1918, a mere seventeen months after the formal American declaration of war. The news touched off enthusiastic demonstrations from coast to coast; ticker-tape swirled. Rival papers dueled with one another over the most punched-up headline. San Antonio was no exception: "EMPEROR ABDICATES," the *San Antonio Light* trumpeted; blared the *San Antonio Express*: "GERMANY GIVES UP."

Yet back at Kelly Field, at least initially, the trainees were in no mood to celebrate: when word reached them, there "was dead silence for about thirty seconds, and then the whole barracks sat up and started cursing at the floor, damning the Germans for having lain down on the job before they had a chance to get over there and prove their merit as aviators."

Their Commander in Chief knew better than to prolong the bloodletting. More than one hundred thousand Americans had lost their lives, another two hundred thousand had been injured, and the nation's wounds—social, political, and economic—went deeper still. That's why President Wilson's "Thanksgiving Address," delivered within days of the armistice, spoke only of pride and hope: "Complete victory has brought us, not peace alone, but the confident promise of a new day as well, in which justice shall replace force and jealous intrigue among the nations." Lauding our "gallant armies" and the "righteous cause" for which they battled, he knew that the American Expeditionary Force had "nobly served their nation in serving mankind." Their accomplishments were a source of great joy: "We have cause for such rejoicing as revives and strengthens in us all the best traditions of our

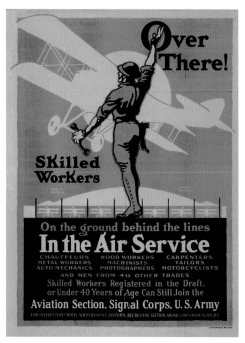

Over There! Lithograph, Courtesy of the Library of Congress

national history. A new day shines about us, in which our hearts take new courage and look forward with new hope to new and greater duties."

It was not to be. On the international front, Wilson's generous Fourteen Points for postwar reconstruction, which included the creation of a League of Nations to guarantee political sovereignty and territorial independence, was undercut by his European allies and his congressional opponents. The domestic arena was troubled as well by a free-falling economy, the deadly Influenza Pandemic, Red-Scare deportations and imprisonments, a brutal crackdown on labor unions, and vicious race riots that ripped through more than twenty-five cities, including Chicago, East St. Louis, and Tulsa. War's end brought little peace.

San Antonio experienced some of this turbulence: as its military infrastructure shut down, commercial activity collapsed, leaving the city's newfound workforce with fewer employment options. That dispiriting situation stabilized by the mid-1920s, only to worsen with the onslaught of the Great Depression, calling into question the wartime sacrifices so many residents had made—the Liberty Gardens they had planted; the natural resources conserved; the War Saving Stamps purchased; and, most devastatingly of all, the loved ones they had lost.

These understandable concerns aside, San Antonio had directly benefited from the First World War: in absorbing millions in federal largesse to train hundreds of thousands of troops, it had built up the city while doing its part to "Beat back the Hun."

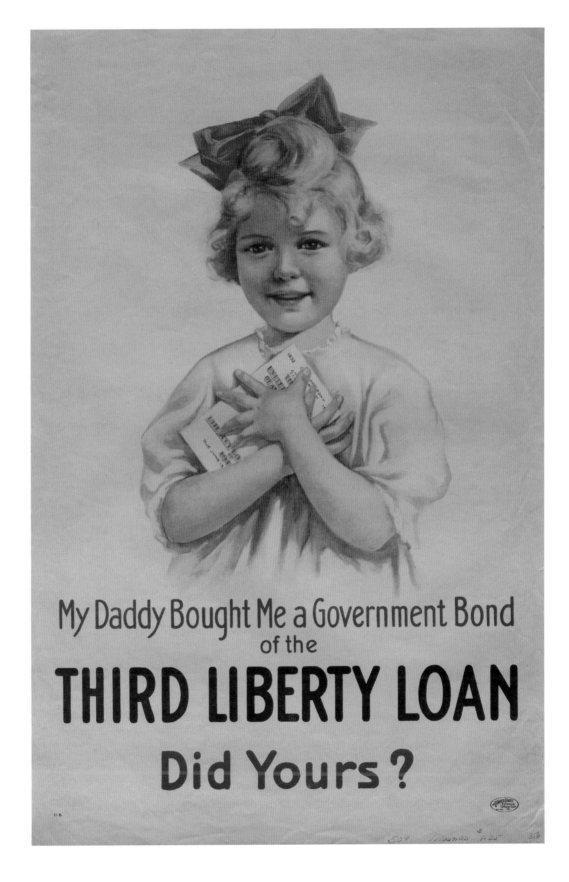

My Daddy Bought Me a Government Bond

Lithograph
31 × 20 inches
Collection of the San Antonio
Public Library

UNCLE SAM WANTS YOU!
AMERICAN ARTISTS' CONTRIBUTIONS TO WORLD WAR I

*Allison Hays Lane, Curator and Director
of the Olana Group, San Antonio, Texas*

War appears to be as old as mankind but peace is a modern invention.
— Sir Henry J. S. Maine, jurist and historian

Decimated forests, tangled barbed wire, a lone figure rising from a trench to leap at an enemy sniper: these are chilling images of the first world war of the twentieth century. The "Great War" of 1914–1918 was such a horrific world conflict that it is incredible that expressions of humanity were able to survive. Never had such deadly weapons as gas warfare, tank attack, and aircraft bombardment been unleashed on densely populated urban areas. Never had the displacement and loss of so many lives occurred; the final toll recorded the decimation of an entire generation.

The First World War was thought to be the war to end all wars, but history has proven this to have been a false hope. The Great War brought the atrocities and anguish of war to the doorstep of European civilization and quickly spread them across the continent.

Prior to the sinking of the SS *Lusitania* in 1915—causing the death of 1,198 civilians including 128 Americans—President Woodrow Wilson had followed policies of isolationism and neutrality. He had urged Americans to remain "impartial in thought and action." Wilson declared war in April 1917, however, prompted by the *Lusitania* event, the assassination of Archduke Franz Ferdinand of Austria, and the discovery of Germany's encouragement of Mexico to invade the United States. The dramatic reversal caught the United States critically unprepared.

President Woodrow Wilson knew the challenges of preparing the country for a military response, but recognized also that the war would effect a major transformation in the life of Americans. To unite the country behind this cause, the government mobilized a domestic information effort unlike anything seen before. To publicize the war effort, Wilson deployed controlled, artistic, appealing propaganda. His goal was to gain public support through an unprecedented mass-marketed campaign.

The humanity of art lies in the artist and not simply in what he represents.
— Meyer Shapiro, art historian

American citizens of 1917 had been insulated from European influences in more than just the political arena. The conservative American art world of the early 1900s was confronted with shifting winds of change blowing into New York City with the 1913 Armory Show. Popularly named for the 69th Street Regiment Armory, the *International Exhibition of Modern Art* presented "new" European work in February and March of that year. Though most of the art selected for the exhibition by William Glackens was the work of American artists, curators Walt Kuhn and Arthur B. Davies chose many modern artists from European art salons and exhibitions.

Even as dramatic new art movements arrived on American shores, many classically trained American artists clung to traditional formats and staid subjects. Even some who had studied in Europe could not relate to the vibrant art movements—such as Dadaism, Italian Futurism, German Expressionism, and, by the war's end, Surrealism—that were sweeping across Europe. This lack of understanding led to a sense of disenfranchisement in the U.S. art community.

The Armory Show was a shock to the system of art in America. The jolt unified some leading American artists of the day—among them Glackens and William Merritt Chase—in retreat from these disruptive and radical foreign influences. A group of artists from Philadelphia, led by Robert Henri, was ready for the fundamental shift. It had begun already in academies and art institutes that were more receptive to new visions and expanded markets. Inspired by the socially committed art of Goya, Manet, Daumier, and others, the Philadelphia group encouraged artists to leave their studios and paint out in the world. The social realism that emerged became known as the Ashcan School. In the years just preceding the First World War, this art depicted realism that many found offensive. Its socially conscious focus was on the plight of the poor and the inner cities.

The roots of modern art, so vital in Europe at the time of the Great War, were not to take hold in the United States until transplanted permanently from Paris to New York City after World War II. Meanwhile, American artists of the pre–World War I era united around their cause. They used art as a medium

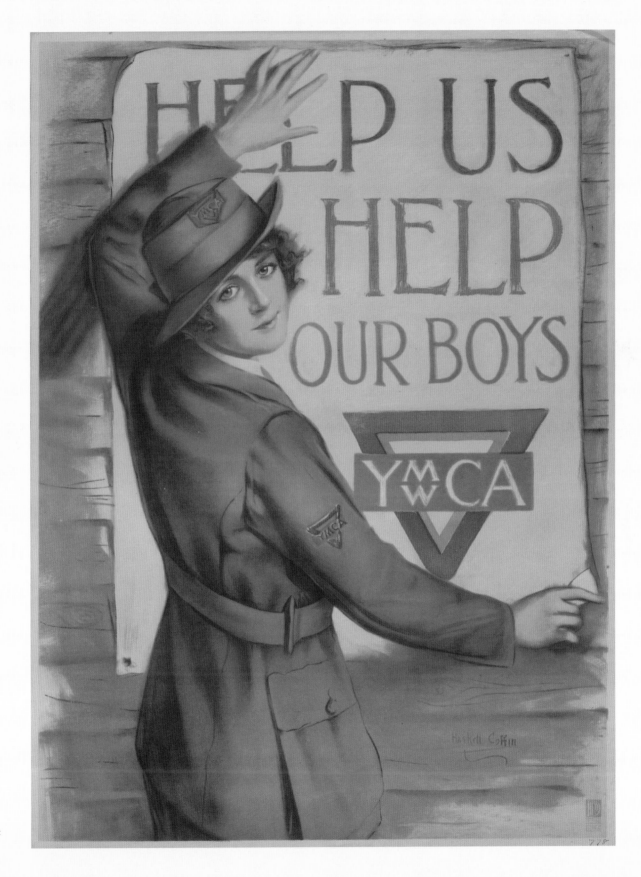

Haskell Coffin
Help Us Help Our Boys
Lithograph
28 × 21 inches
Collection of the
San Antonio Public
Library

to protect artistic values in the United States and to support artistic freedoms in Europe.

I ask and expect only support of those who believe that for the sake of political liberty and social progress, America must win this war while it consolidates at home every position won from the forces of reaction and political bigotry.

—George Creel, Chairman
Committee of Public Information, March 1918

To unite the country behind the war effort, President Wilson turned to leaders in the arts, journalism, and advertising. Investigative journalist George Creel caught Wilson's vision and ran with it. Creel had begun his newspaper career at the *Kansas City Star* in 1894. He founded the *Kansas City Independent* in 1899 and later wrote for two Colorado papers, the *Denver Post* and the *Rocky Mountain News.*

President Wilson appointed Creel Chairman of CPI, the Committee on Public Information. The CPI was created April 13, 1917, as America's propaganda ministry to promote patriotic spirit in support of the U.S. military and to strengthen resolve against the enemy. Creel used his journalistic influence to enlist support for the war in the editorial pages of national newspapers, on billboards, and with advertising.

Creel hired more than 75,000 "four-minute men" to speak at rallies, movies, theaters, stadiums, and school auditoriums on behalf of the war effort. (Four minutes was approximately the time it took to change reels for movie news shorts.)

These highly charged patriotic talks led to the recruitment of artists, photographers, and writers to develop images and text to foster the war effort. They created posters, advertisements, and articles to "sell" Liberty Bonds, Red Cross drives, War Savings Stamps, and other national services. Film producers made war movies to keep the public engaged and aware of current events. Film stars such as Charlie Chaplin took to the stage to stir patriotic fervor.

Thousands of promotional images were created to illustrate the war effort. The poster had become prominent as an art form in the late 1800s with established artists Alphonse Mucha and Henri Toulouse-Lautrec. Both were masters at blending the artistic and marketable aspects of the poster format by planting ideas with striking images in graphic color and design. In the United States, the poster dramatized the war and the American experience as no other art form had done.

The poster became the great "equalizer" of American culture. Addressing the issue of supporting the war endeavor in buying bonds

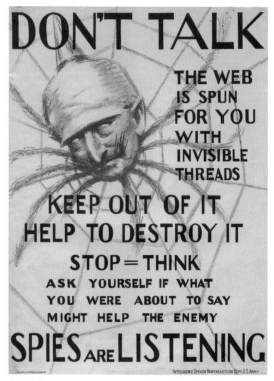

Don't Talk
Lithograph
28 × 21 inches
Collection of the San Antonio
Public Library

and stamps, Americans recognized themselves in the poster imagery as patriotic participants in the war. Just as the theater poster attracted an audience to a show, the war poster appealed to citizens by conveying a message of urgency, unity, and national pride.

At this time the government began monitoring information relayed in and out of the country by cable and telegraph. Even news bureaus were monitored to ensure that they were not revealing movements or locations of troops, ships, or military operations. At George Creel's urging, many members of the press accepted a patriotic responsibility to limit explicit coverage. News agencies cooperated in order to avoid punitive damages and accusations of treason. There was some compensation, however, in government-purchased advertising.

If there had been any doubt about President Wilson's intentions to control information, it would have been dispelled on June 15, 1917, when he signed the Espionage Act that established the Censorship Board. Creel was a vocal member of this board, which had

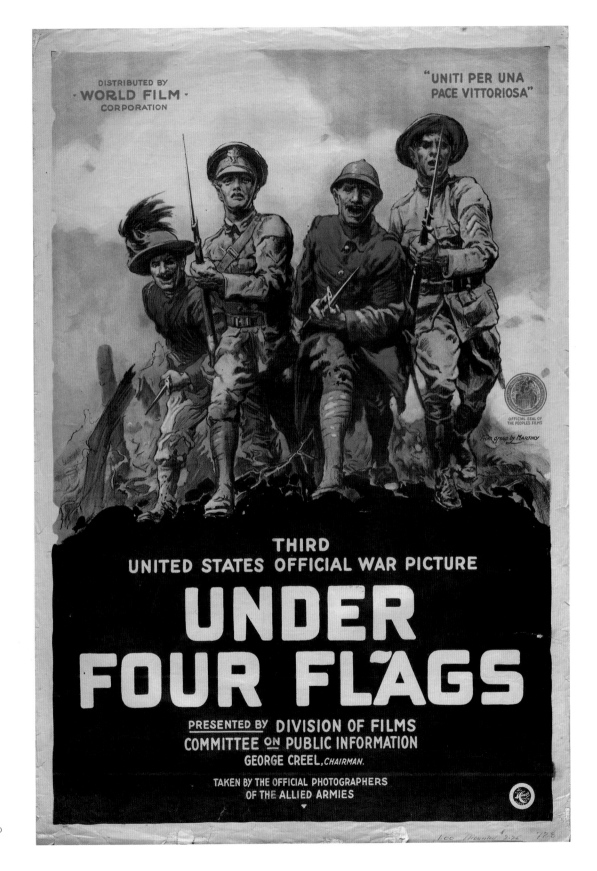

Under Four Flags

Lithograph
41 × 21 inches
Collection of the San Antonio
Public Library

Ellsworth Young
Remember Belgium
Lithograph
29 × 19 inches
Collection of the San Antonio
Public Library

power to monitor and control the flow of information to the public. To contemporary interpreters of the First Amendment, it is incredible that less than one hundred years ago, a select federal government committee was empowered to usurp the First Amendment constitutional right of the press.

By the end of the World War I conflict, Creel had forfeited the respect of his journalistic colleagues. He was criticized for his implacable stance and reprisals against reporters who had not adhered to Censorship Board guidelines.

No artist is too great to come and give his best.
— Charles Dana Gibson, artist and illustrator

In April 1917 George Creel and the Committee of Public Information (CPI) called upon renowned artist Charles Dana Gibson to lead the Division of Pictorial Publicity for CPI. Just one day after the United States declared war, the Society of Illustrators met at the Hotel Majestic in New York City. Members discussed how they could become involved in the war effort immediately. They even considered forming a group called "the Vigilantes."

Gibson set to work recruiting popular illustrators, cartoonists, and artists, many of whom eagerly volunteered their services to create approximately 700 designs for more than 50 government agencies. Service agencies such as the Jewish Welfare Board, YMCA and YWCA, Catholic Relief, and Red Star—a service that protected animals deployed for the war—targeted their own constituencies.

Propaganda posters, banners, advertisements, and leaflets were printed in the thousands and distributed to hospitals, churches, synagogues, schools, college campuses, factories, and city halls to reach the maximum number of people in both rural and urban areas.

Printed in many languages, the posters were meant to appeal to European immigrants also. Recruitment offices opened in immigrant communities whose homelands were impacted by the war: Poland, Belgium, Serbia, France, Britain, and Czechoslovakia. The use of French, Yiddish, Polish, and Czech languages gave the propaganda a distinctly international flavor.

An undercurrent of the poster message was to educate newly arrived citizens about their patriotic duties and loyalty to America. Many new members of art academies and art guilds, such as Polish artist and illustrator W.T. Benda, were recent immigrants. Benda's passionate illustrations evoked Polish history and called for the protection of Poland.

When the United States wished to make public its wants, whether of men or money, it was found that art — as the European countries had found — was the best medium.

— Joseph Pennell, artist and illustrator

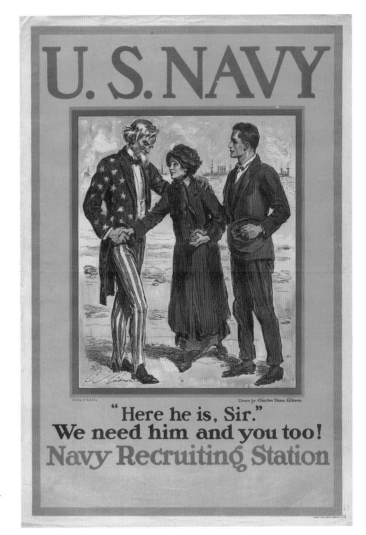

Charles Dana Gibson
U.S. NAVY
Lithograph
41 × 28 inches
Collection of the San Antonio
Public Library

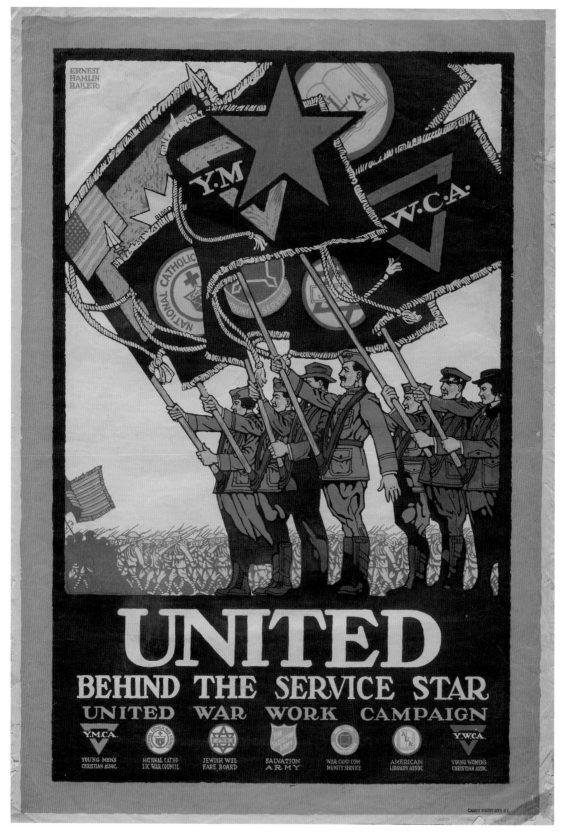

UNITED Behind the Service Star

Lithograph
41 × 20 inches
Collection of the San Antonio
Public Library

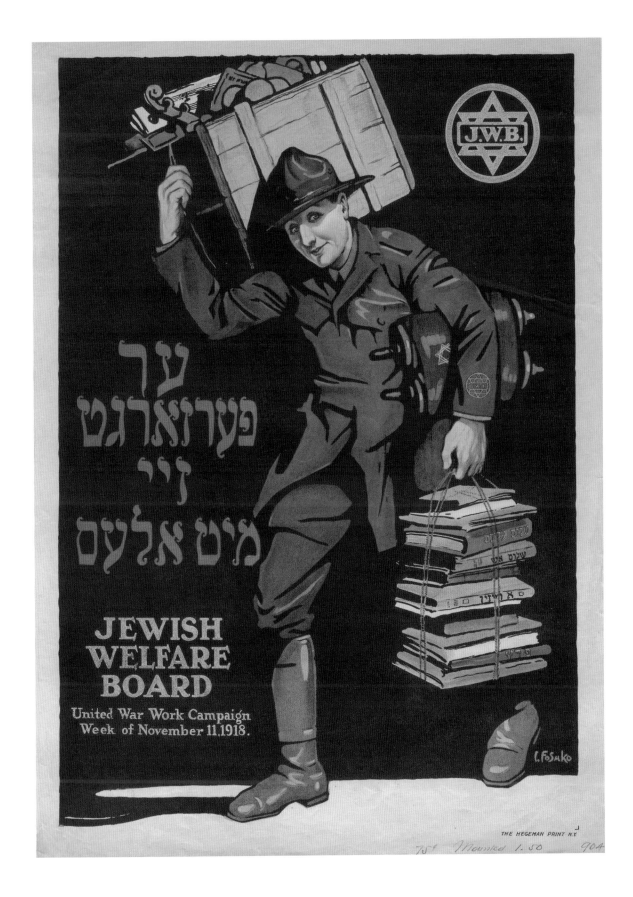

J. Fosuko
Jewish Welfare Board

Lithograph
28 × 20 inches
Collection of the
San Antonio Public
Library

The patriotic poster played the central propaganda role as both artistic medium and marketing tool. The directness of the poster made it the perfect equalizer by addressing all Americans, whatever their background or region of the country. Dramatic and colorful images, in patriotic themes of protecting hearth and home, became welcome and familiar.

In another cultural shift, the strong female character became familiar in many poster designs. Building on the progress of the Woman's Suffrage Movement and foreshadowing Rosie the Riveter of the Second World War, portrayals of women shifted to depictions as soldiers, sailors, workers, rally organizers, and nurses on the front lines. Also, in contrast, female figures were placed on a pedestal in romanticized versions of Liberty, Columbia, and Joan of Arc.

Artists committed to the CPI propaganda project were invited to meet Friday evenings in New York City and adjourned to dinner afterward for more sharing of creative ideas. Gibson was well established and highly respected for his popular Gibson Girls and *Life* magazine art. Gibson instigated the development of inspiring new ideas and methods of conveying them. Artists received assignments and submitted original works on canvas or mat board for approval by CPI. The pieces were then reproduced in large print runs by leading lithography companies. Some printing companies of German origin, eager to demonstrate patriotism, provided the government with their services and state-of-the art printing techniques.

Rallies, parades with marching bands, and other public gatherings were flag-waving opportunities for unfurling large banners from balconies and windows. Classic American symbols such as Columbia, the Statue of Liberty, and Uncle Sam were juxtaposed with pictures of ordinary citizens—fathers, mothers, children, and workers—all doing their patriotic part. Male figures, depicted as superhuman in stature, were shown building boats or loading cargo ships.

The blood-drenched boot of a German soldier stepping on the map of the United States and the Kaiser listening as a spider and spy are examples of powerful poster images. The new popularity and prevalence of the poster afforded artists the opportunity to create a breathtaking iconographic vocabulary, bold and passionate, speaking directly to the American public. Poster artists knew their marketplace. With experience as commercial illustrators and training in fine art academies, they could refer to European precedents and interpret their subjects in bold color lithography. The compositions were meant to seduce the viewer with color and form and deliver the urgent patriotic punch.

The poster viewer was meant to become inspired and actively engaged in the war effort. People were asked to contribute looking glasses, telescopes, books, and even farm animals—all to help feed the hungry military machine. Citizens were asked to make

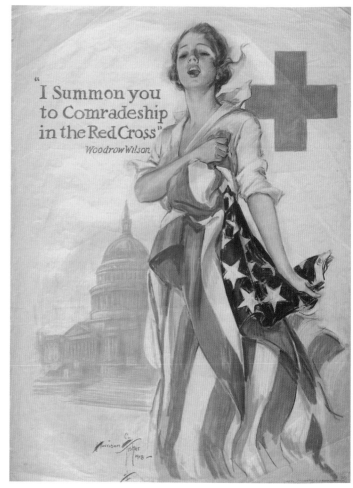

Harrison Fisher
"I Summon you to Comradeship in the Red Cross"

Lithograph
39½ × 30¼ inches
Collection of the San Antonio Public Library

Learning from his father, the landscape painter Hugh Antoine Fisher, Harrison Fisher (1875–1934) demonstrated an aptitude for art from an early age. While still in his teens, Fisher began drawing for the *San Francisco Call* and later the *Examiner*.

Fisher made his contribution to *Cosmopolitan* and *Puck Magazines* featuring fresh-faced young women of the beginning of the century. His pastel drawings led to a later successful career doing portraits. His luminous female faces often rivaled the "Gibson" or "Christy" girls.

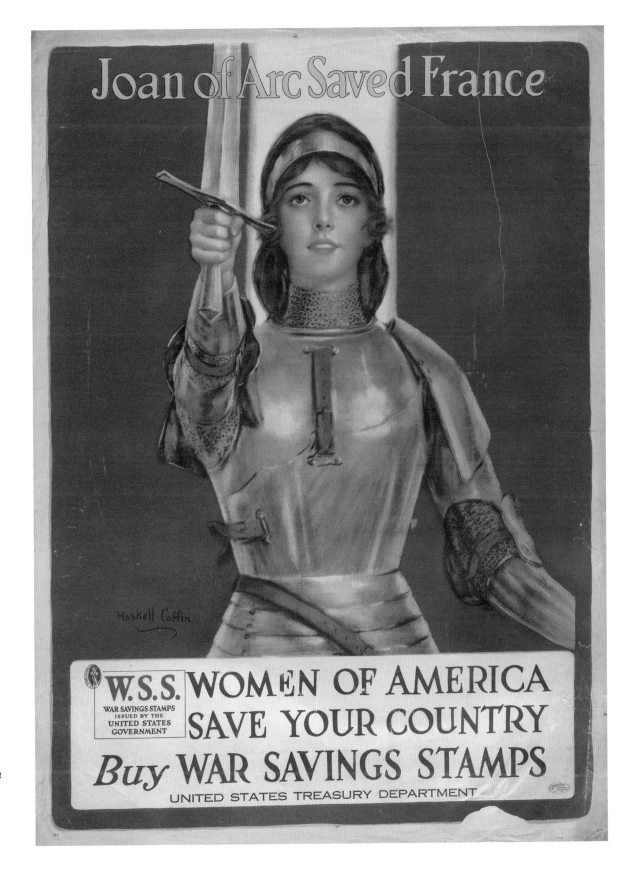

Haskell Coffin
Joan of Arc Saved France

Lithograph
40 × 30 inches
Collection of the
San Antonio Public
Library

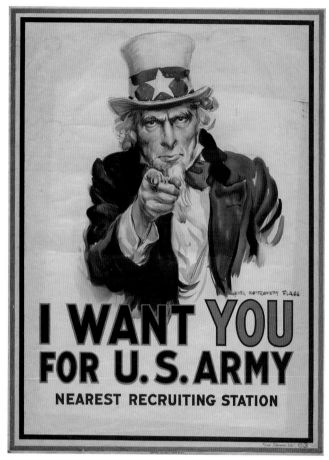

James Montgomery Flagg
I Want YOU For U.S. Army
Lithograph
40 × 30 inches
Collection of the
San Antonio
Public Library

The rebel and bohemian in the group was James Montgomery Flagg. He is best known for his rendition of Uncle Sam, perhaps the most iconic image in American culture. Ironically, the image was borrowed from an early picture by British artist Alfred Leet, showing British Admiral Kirchner saying, "Your Country needs YOU!" Using his own likeness for Uncle Sam, Flagg never worried about borrowing the idea. He never reaped substantial financial benefit from this image, which belonged to the government.

The Committee for Public Information decided to publicize the committee's work and asked artists to work in public view. They demonstrated how they produced posters on behalf of the war effort. Flagg jumped at the chance to paint on the steps of the New York City Public Library at Fifth Avenue and 42nd Street. Working from a live, flag-draped model, showman Flagg delighted in attracting a crowd and creating good public relations for the committee.

Many CPI artists were already colleagues through their studies, work, or guilds. They were principals in the dynamic and ever-evolving art scene in New York City and many had reputations for flamboyant antics. A pastime for some was writing short plays about current events. Their bawdy performances enlivened parties of their peers at the Dutch Treat or Lotus Clubs.

At the peak of the CPI's Division of Pictorial Publicity's power in 1917–1918, it employed more than three hundred artists in its mission. Not until the projects of the Works Progress Administration in the Great Depression, 1930–1935, would the government hire as many artists in a national program. Again, in the 1930s, the government provided work for the artists in their communities painting murals in federal buildings, making furniture in schools, and building parks and river walks. The artists' public role was considerably different during World War I than in the 1930s and 1940s. Both known and anonymous artists were engaged to "sell" the moral validity of World War I

The combined, concerted artistic effort fueled the propaganda that propelled the country through the First World War. It solidified domestic support and created a positive national self-image. For the United States of America, the voices and visions that arose from this unique time projected a strong new identity at home and that of a world leader abroad.

The government's call to action of the American artistic spirit raised the patriotic consciousness of the country. What had begun as cooperation in a mission of duty burgeoned into a full-fledged art movement, an artistic expression of national pride and power.

But now as I study that row upon row of wind-blown engravings I feel satisfaction, deep down in my star spangled heart, for I know how art put on khaki and went into action.
—Wallace Irwin, "Thoughts Inspired by a War-time Billboard"

sacrifices such as refraining from eating the foods to be sent overseas. These poster images still resonate in another century.

Established illustrators of the day who joined Charles Dana Gibson's Division for Pictorial Publicity included Howard Chandler Christy, Haskell Coffin, Cushman Parker, Edward Penfield, Joseph Pennell, Sidney Riesenberg, Frederick Strothmann, and Edmund C. Tarbell. The committee roster read like a "Who's Who" in American art. Many members had belonged to art guilds, such as the Society of Illustrators, the National Academy of Design, or the Society of American Artists. Representing all ages and backgrounds, artists shared their passion and creative energy to perform in their country's interest.

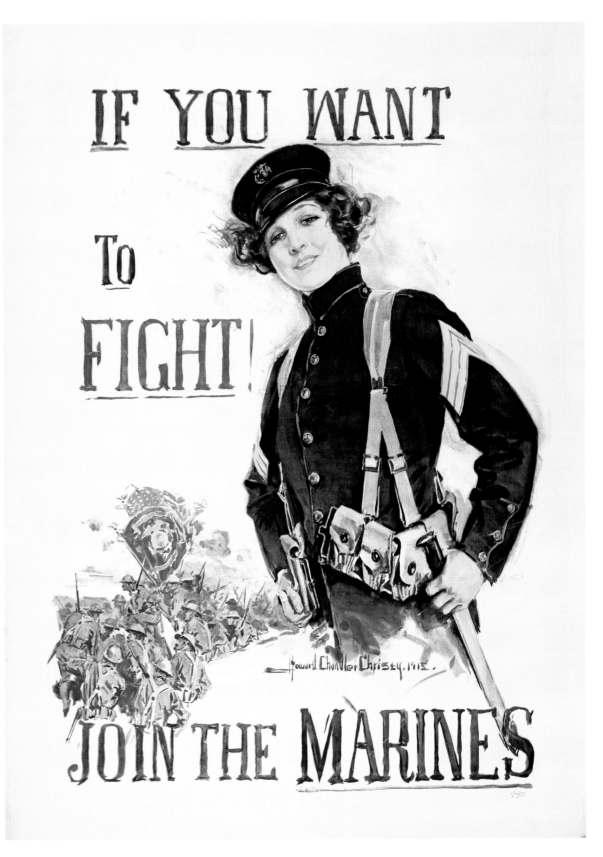

Howard Chandler
Christy
**If You Want To Fight!
Join The MARINES, 1915**

Lithograph
39 × 30 inches
Collection of the
San Antonio Public
Library

"I HAD NOT THOUGHT DEATH HAD UNDONE SO MANY"
WRITERS OF WORLD WAR I

Jeanne C. Reesman, Ph.D.
University of Texas at San Antonio

Like the poster artists, writers from many nations recorded their views of the events of World War I. After the United States entered the war in April 1917, American writers joined European authors in recording the "Great War," as it was called, that had begun in 1914. Until armistice with Germany in 1918, four years of brutality shook the world, marking the end of the sense of the old European civilization. By the war's end, nearly nine million lives had been lost—more than would be lost in World War II—including virtually an entire generation of young British men. The prolonged horrors of the war were felt especially at the Western Front, which seemed to be permanently stuck, with both sides entrenched and forced to make costly and fruitless attempts to break the stalemate. Instead of peaceful countryside, Western Europe devolved into desolation as the war took its toll in blasted trees and ruined farms destroyed by artillery. Barbed wire and rows of flooded and rat-infested trenches crisscrossed the landscape. There was little food or medicine. Though a sense of honor sent many to war, for many this ideal was dashed by their experience in the trenches. The scale of World War I's casualties thus helped lead to the disturbing tendency to reject traditional ideals and to lean toward an overall sense of failure and fear in traditional institutions. Despite their shared tone of lament, horror, and gloom, by rediscovering and joining the traditions of the past with the possibility of voices and visions entirely new, writers of this period found in modernism a means of expressing in art both the sacrifices at home and those which led to the heroic but costly victory of the Allied Powers.

British war poets and fiction writers begin with Rupert Brooke (1887–1915), author of the poem "The Soldier" (1914), which reflected the patriotism and optimism of war posters by appealing to the idea of England as immortal. It begins, "If I should die, think only this of me:/That there's some corner of a foreign field/That is for ever England," and concludes with an image of "hearts at peace, under an English heaven." Mrs. Mary Humphry Ward (1851–1920) was a popular novelist in England and the United States before and after the war and the first woman journalist to be sent to the Western Front. Because of her popularity in America, the

British government's War Propaganda Bureau asked her to write a book encouraging Americans to support Britain's war effort, as do many of the war posters; the result is titled *England's Effort* (1916).

Other British authors took a darker view of the war. Such writers included Wilfred Owen (1893–1917), author of the poem "Dulce et Decorum Est," who enlisted in the Artists' Rifles (the 38th Middlesex Rifle Volunteers, formed in 1860, consisting of painters, sculptors, engravers, musicians, architects, and actors); Robert Graves (1895–1985), author of *I, Claudius* (1934); Siegfried Sassoon (1886–1967), author of *The Old Huntsman* (1917), *Counter-Attack* (1918), and *Memoirs of an Infantry Officer* (1930); and W. Somerset Maugham (1874–1965), who became an internationally popular playwright, novelist, and short-story writer. Margaret Sackville (1881–1963), a poet, children's author, and antiwar advocate, was one of the best-known women writers of World War I Britain, and Dorothy Lawrence (1896–1964) actually disguised herself as a man in order to serve in the army. British women, like their American counterparts, are portrayed as strong and vigorous on the war posters.

Among American writers of World War I were some who served in the war but many who did not; they reacted more to the postwar sense of despair and futility. First among these was Thomas Stearns Eliot (1888–1965), or "T. S." Eliot, born in St. Louis, Missouri, and educated at Harvard University, later a citizen of the British Empire. A number of Eliot's works capture the eerie aftermath of battle and even more so the destruction of traditional social, political, religious, and cultural ideals in the period after the war.

Eliot's masterpiece *The Waste Land* (1922) and other major poems such as "The Hollow Men" (1925) lament the end of an age, but through their shocking new images of modern civilization and new poetic form—long, fragmented structures that seemed to capture the overall mood of uncertainty after the war—they spoke to a generation fundamentally changed and interested in new ways of creating order. *The Waste Land* makes innovative use of multiple voices, allusions to dozens of ancient and modern literary and mythological traditions, and surrealistic montages. Quotes from the Bible,

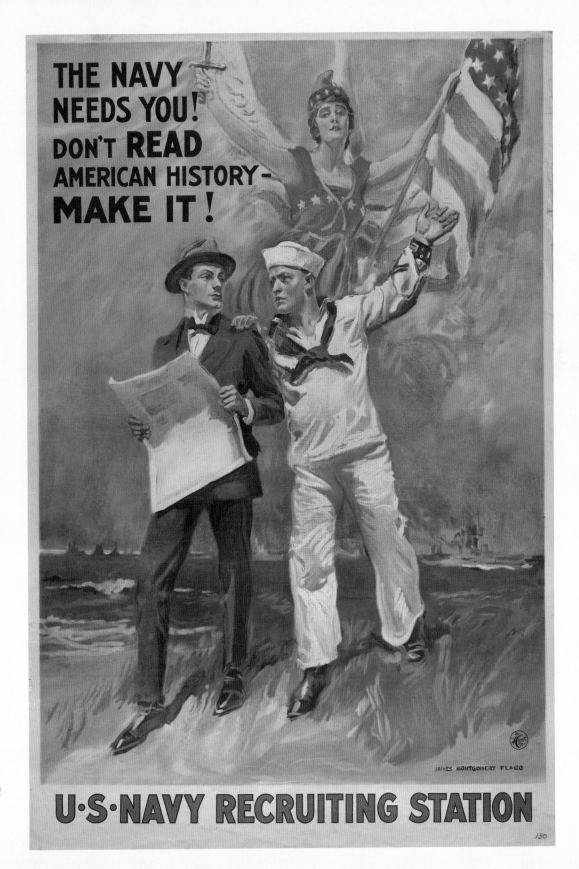

James Montgomery Flagg
THE NAVY NEEDS YOU! DON'T READ AMERICAN HISTORY — MAKE IT!

Lithograph
41 × 27 inches
Collection of the San Antonio
Public Library

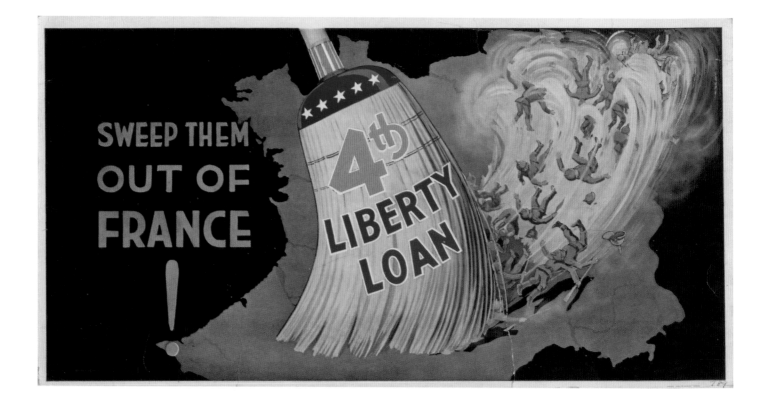

Sweep them out of France!
4th Liberty Loan

Lithograph
11 × 21 inches
Collection of the San Antonio
Public Library

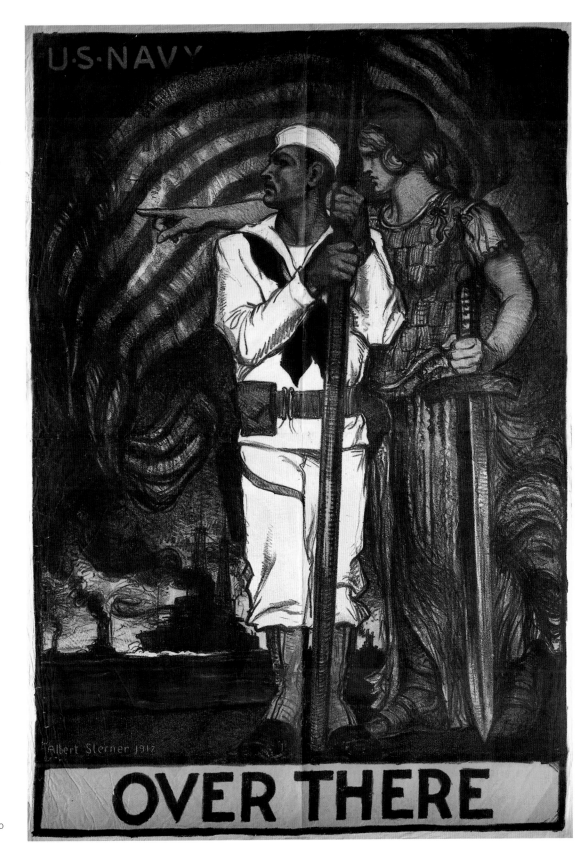

Albert Steiner
U·S·NAVY OVER THERE, 1917

Lithograph
96 × 60 inches
Collection of the San Antonio
Public Library

Shakespeare, and Dante are punctuated by modern voices—drunk, bored, victimized, and unfeeling. How could the horrors of the war take place among civilized nations? the poem seems to ask. Eliot finished *The Waste Land* in a Swiss sanatorium after suffering a nervous breakdown brought on by depression. "These fragments I have shored against my ruins," the Fisher-King of the poem explains, but there is no clear resolution or even a future definitely indicated in the poem's apocalyptic vision, though it is implied in the concluding Sanskrit prayer for peace. But images of the war persist:

> Unreal City,
> Under the brown fog of a winter dawn,
> A crowd flowed over London Bridge, so many,
> I had not thought death had undone so many.
> Sighs, short and infrequent, were exhaled,
> And each man fixed his eyes before his feet.
> Flowed up the hill and down King William Street,
> To where Saint Mary Woolnoth kept the hours
> With a dead sound on the final stroke of nine.

Though the poem contains military and war references, it focuses not upon battlefield scenes but upon the human cost—emotional, spiritual, and cultural—and upon individuals who struggle with their postwar grief, sense of alienation, and economic entrapment.

Similarly, "The Hollow Men" expresses personal and cultural emptiness:

> We are the hollow men
> We are the stuffed men
> Leaning together
> Headpiece filled with straw. Alas!
> Our dried voices, when
> We whisper together
> Are quiet and meaningless
> As wind in dry grass
> Or rats' feet over broken glass
> In our dry cellar. . . .
>
> Those who have crossed
> With direct eyes, to death's other Kingdom
> Remember us—if at all—not as lost
> Violent souls, but only
> As the hollow men
> The stuffed men.

The narrator struggles with belief in God as he surveys the broken world and wonders how it can be put back together, but the poem ends with the tragi-comic refrain:

> This is the way the world ends
> This is the way the world ends
> This is the way the world ends
> Not with a bang but a whimper.

Erroneously captured as a spy by the French, E. E. Cummings (1894–1962) wrote his memoir *The Enormous Room* (1922) about his experiences as a prisoner of war. In his poetry he also used his experience as an ambulance driver in France after the United States entered the war. In his clever, enigmatic, and often very brief poems, with their lowercase typography and oddly conversational experiments in neologism and line length, he dramatized the position of individuals against the institutional forces that depersonalize them. His poetry, despite at first appearing light in tone, is anything but. Cummings's use of irony in such poems as "Buffalo Bill's" (1920) is savage:

> Buffalo Bill's
> defunct
> who used to
> ride a watersmooth-silver
> 　　　　　　　　stallion
> and break onetwothreefourfive pigeonsjustlikethat
> 　　　　　　　　　　　　　　　　Jesus
> he was a handsome man
> 　　　　　　　　　　and what i want to know is
> how do you like your blueeyed boy
> Mister Death

In "killing" Buffalo Bill, a beloved American symbol whose image would have appeared on patriotic propaganda such as war posters, Cummings startlingly combines everyday popular culture with the shocking realities of the war. Similarly, the poem "I sing of Olaf glad and big" starts out with a cheerful portrait of a young man, but as in Sassoon's "Suicide in the Trenches" it unsparingly relates how his decision to be a conscientious objector results in terrible punishment. Similarly, civil rights and suffrage crusader Ida B. Wells-Barnett (1862–1931), writing for the *Chicago Tribune*, campaigned for racial equality in the U.S. Army during the war, including publicizing the unfair executions of black soldiers for minor offenses. None of these writers meant to be unpatriotic (unlike Ezra Pound, who espoused Fascist ideology during World War II), but they wished to express through art both the sacrifices of the past and the desperate desire for a meaningful future.

After high school, Ernest Hemingway (1899–1961) became a reporter on the *Kansas City Star*. When the United States entered the war, Hemingway, aged 18, attempted to join the army but was

Artist's Rifle Regiment Badge, Courtesy of the Artist's Rifle Association

rejected because of defective eyesight. Learning that the Red Cross was seeking volunteer ambulance drivers, he signed up in April 1918 and left his job at the newspaper to sail to Europe. In early June he first went to Paris, then to Milan after receiving his orders. In the war he became a decorated hero, for within a few months of reporting to the Austro-Italian front he carried a wounded comrade to safety even though severely wounded himself.

Already on the first day Hemingway reported for duty, he received a harsh introduction to the war: a munitions factory exploded, and he had to carry mutilated bodies and body parts for cataloging and reburial. He was then deployed to drive an ambulance, which he did, but on July 8, 1918, only a few weeks after arriving at his new post, he was seriously wounded by numerous shrapnel fragments from an Austrian mortar shell that landed near where he had been distributing chocolate and cigarettes to Italian soldiers in the trenches. The explosion knocked him out, killed a soldier, and took the legs of another. In a letter to Hemingway's father, a fellow ambulance driver wrote that despite his wounds,

Hemingway still managed to carry another wounded soldier back to the first-aid station and that along the way he was hit again in the legs by machine gun bullets. He was awarded the Italian Silver Medal for Valor with the citation, "Gravely wounded by numerous pieces of shrapnel from an enemy shell, with an admirable spirit of brotherhood, before taking care of himself, he rendered generous assistance to the Italian soldiers more seriously wounded by the same explosion and did not allow himself to be carried elsewhere until after they had been evacuated."

Hemingway was hospitalized in Milan, where he met and fell in love with a nurse, retold in his novel *A Farewell to Arms* (1929). In that novel, the hero, Frederic Henry, behaves admirably when tested in the fighting, but later dejectedly remarks of the war, "I was always embarrassed by the words sacred, glorious, and sacrifice and the expression in vain. . . . I had seen nothing sacred, and the things that were glorious had no glory and the sacrifices were like the stockyards at Chicago if nothing was done with the meat except to bury it. There were many words that you could not stand to hear." Another of Hemingway's most characteristic passages on World War I also occurs in *A Farewell to Arms* when Henry observes, "The world breaks everyone and afterward many are strong at the broken places. But those that will not break it kills. It kills the very good and the very gentle and the very brave impartially. If you are none of these you can be sure that it will kill you too but there will be no special hurry." Such forebodings do not, however, excuse his heroes from fighting bravely to their very limits.

Similarly, *The Sun Also Rises* (1926), an earlier novel about the aftermath of the war, takes a more sardonic view of the personal suffering entailed by the war. The hero, Jake Barnes, has been left sexually impotent from his war injuries, and though he tries to live by a stringent personal code of dignity, it is not enough to protect him from his battlefield memories and also the emotional aimlessness of the American and British expats who surround him in Paris; he and they are what Hemingway called the Lost Generation.

In these two World War I novels, Hemingway created a certain kind of American hero who is, as Leslie Fiedler argued in his study *Love and Death in the American Novel*, the modern version of the classic American literary hero. He lives by a code that requires him to be stoic, brave, and self-sufficient; the ultimate loner, he is uncomfortable in polite society. He is often an artist. This hero demonstrates in war and in "normal" life Hemingway's definition of courage— "grace under pressure"—which he saw as the masculine ability to remain calm and competent in the face of life-threatening violence. Hemingway heroes accept not only physical suffering and wounds, but even worse, the pain of losing those they love whether in war

or in peacetime. His heroes attempt to deflect their troubled emotions by pursuing obsessively certain male-defined activities, such as drinking, hunting, fishing, attending a bullfight, or ordering food and wine—even going to war—as a sort of existential personal realm of controlled yet creative living that can find meaning in the fragments of a wounded world and through a wounded psyche. These men are, in Hemingway's words, "hurt very badly; in the body, mind, and spirit, and also morally." World War I casts a shadow over these characters in that they no longer believe in nineteenth-century traditions and values, but they are not really cynics. Though disillusioned, they are still idealists, even if they reject nationalist propaganda and simplistic, romantic views of life. The Hemingway code is also exemplified in his characters Robert Jordan in *For Whom The Bell Tolls* (1940) and the Cuban fisherman Santiago in *The Old Man and the Sea* (1952).

The Hemingway hero not only reappears throughout Hemingway's career but has had enormous influence on later writers and artists, from Raymond Chandler and James Ellroy to the movie characters portrayed by actors Humphrey Bogart and John Wayne, to Norman Mailer and John Updike, to contemporary American writers Russell Banks, Raymond Carver, Tim O'Brien, and Cormac McCarthy.

John Dos Passos (1896–1970) was born in Chicago to a well-to-do family of Portuguese Americans. After graduating from Harvard University, impatient with the United States' delay in entering the war, in 1917 he joined the British Red Cross volunteer ambulance corps in which Maugham, Cummings, and Hemingway also served. When the United States declared war, he became a U.S. Army medical corpsman. He was later famous for his experimental novel the *U.S.A.* trilogy (1938), a major piece of leftist fiction critiquing the decade of the Great Depression and satirically surveying the superficialities of materialism and greed, largely by using newspaper headlines and popular culture. Shortly after the war, however, his novel *Three Soldiers* (1921) bitterly told of three young men of varying backgrounds who are destroyed by their war experiences. Like the other writers, Dos Passos took a dark view of overly optimistic war slogans, especially as they seemed too easy when recalled in the trenches. He focused instead on individual fear and uncertainty.

William Faulkner (1897–1962) is not primarily thought of as a writer of World War I, but the sense of a world collapsed without a future is certainly one of the most distinctive themes in his novels and stories of the fall of the Old South. And it arises in part from his understanding of World War I. Having dropped out of high school in 1915, Faulkner enlisted in the British Royal Flying Corps and was sent to Canada to train as a pilot. However, the war ended

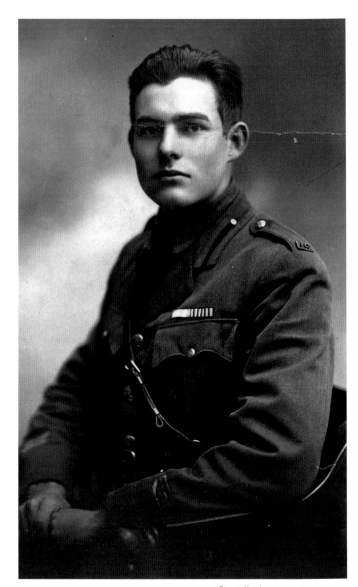

Ernest Hemingway, 1918

Milan, Italy
Ernest Hemingway
Photography Collection
John F. Kennedy Presidential
Library and Museum, Boston

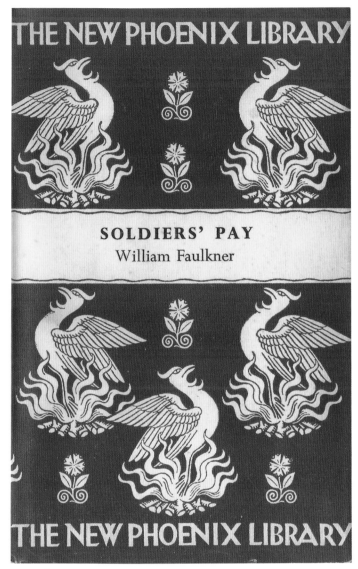

William Faulkner
Soldiers' Pay
The New Phoenix Library
Illustrated cover
Courtesy of Special Collections Library, University of Michigan

in 1918 before he ever saw service or even learned to fly. He may not even have been up in a plane. Yet when he returned to Oxford in 1919, he told dramatic stories of being wounded behind German lines, even affecting a limp and claiming he had a steel plate in his head; he took to wearing an RAF lieutenant's uniform around the town square. Faulkner did not give up these stories until Joseph Blotner started writing an authorized biography after Faulkner won the Nobel Prize in 1950. The intense meaning of war service for young men of his generation—the hopes for heroism in particular—is clear in the case of a famous writer who still felt the need to be a war hero.

Faulkner's works, like Eliot's *The Waste Land*, generally reflect the modernist sense of fragmentation and alienation followed by an ambiguous resolution. Several are set in World War I, including the novel *Soldier's Pay* (1926), about an injured soldier returning home, the allegorical novel *A Fable* (1954), and some short stories. Faulkner's novel *As I Lay Dying* (1930) expresses the general postwar despair indirectly but powerfully within the lives of one poor rural family. The main character, Darl, is a shell-shocked young soldier returned home to his tenant farmer family. The book is told in unconnected fragments from various narrators, either members of or observers of the Bundren family, beginning with the shiftless father, Anse, and the bitter and disillusioned mother, Addie. Addie's death furnishes the plot of the novel, as her feuding children try unsuccessfully to bury her. Darl narrates most of the story, focusing on the bitter relationships between family members. Though many members of the family, including Anse's new wife, get what they secretly hoped for from a trip to Jefferson, in the end, Darl's phantasmagorical, disconnected, nearly incoherent narrative is cut short when he is sent to the state mental farm by his family, perhaps for seeing them too well. Some critics believe Darl is also influenced by the new art movement of Cubism, which many young Americans during and after World War I saw on display in Paris, including William Faulkner—but only *after* the war.

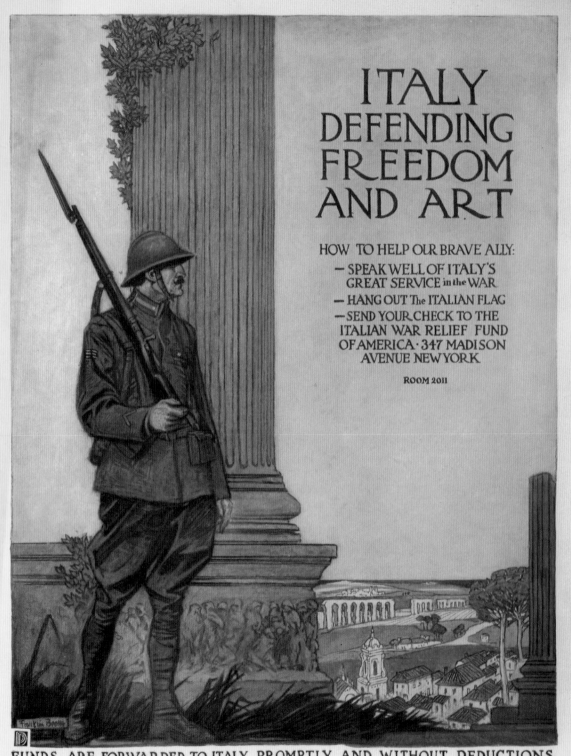

Franklin Booth
Italy Defending Freedom and Art
Lithograph
19½ × 15½ inches
Collection of the San Antonio
Public Library

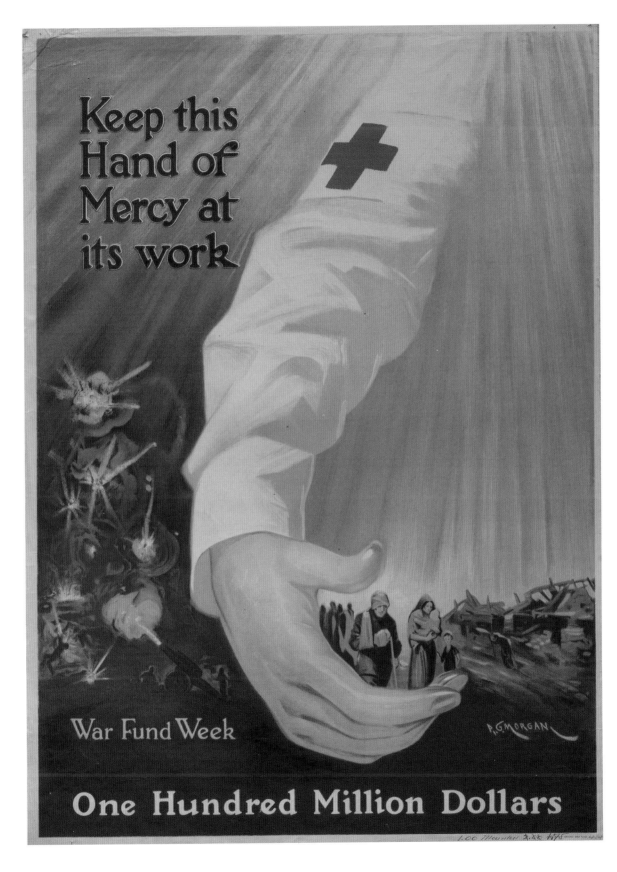

P.G. Morgan
Keep this Hand of Mercy at its work

Lithograph
28½ × 20 inches
Collection of the
San Antonio Public
Library

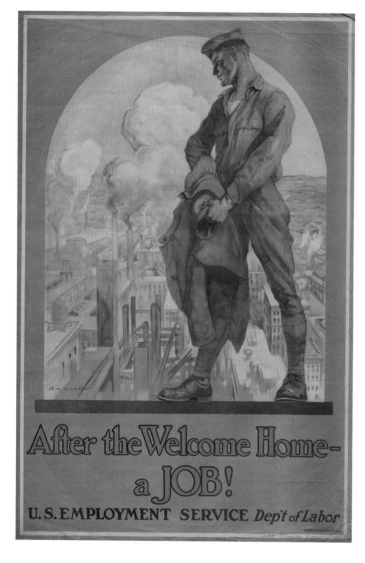

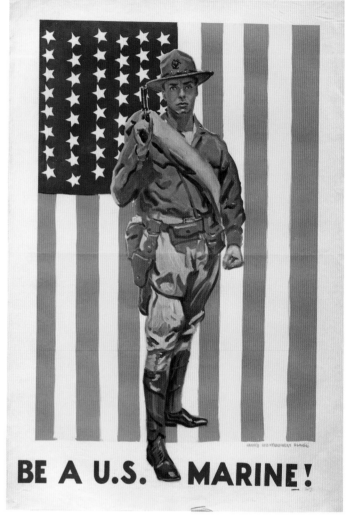

Edmund M. Ashe
After the Welcome Home — a JOB! 1919

41⅛ × 27½ inches
Lithograph
Collection of the San Antonio
Public Library

Edmund M. Ashe (1867–1941) was an original member of the Society of Illustrators. As an artist correspondent during the administration of Theodore Roosevelt, he developed a friendship with the President. In addition to being a renowned magazine illustrator, a master of pen-and-ink medium, Ashe was a famous teacher at the Art Students League and Carnegie Institute of Technology. The subject of employment for returning veterans is one that resonates today.

James Montgomery Flagg
Be a U.S. Marine!

Lithograph
40 × 28 inches
Collection of the San Antonio
Public Library

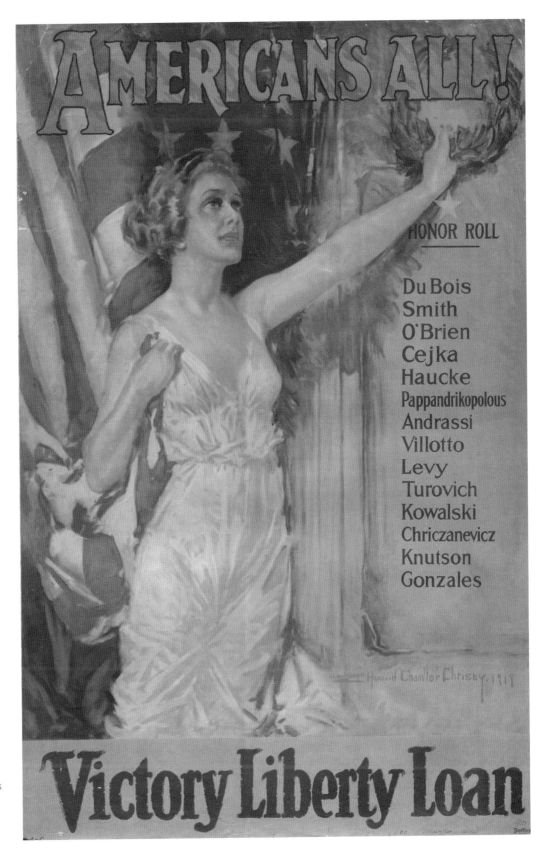

Howard Chandler Christy
AMERICANS ALL! Victory Liberty Loan, 1919

39½ × 27½ inches
Lithograph
Collection of the San Antonio
Public Library

This image by Howard Chandler
Christy (1873–1952) reflects a classi-
cally draped female figure honoring
the roll of American war casualties.
Christy's use of a classical figure
shows his artistic grounding in studies
with his mentor and teacher William
Merritt Chase. The names listed dem-
onstrate the diversity of American
participation in the conflict.

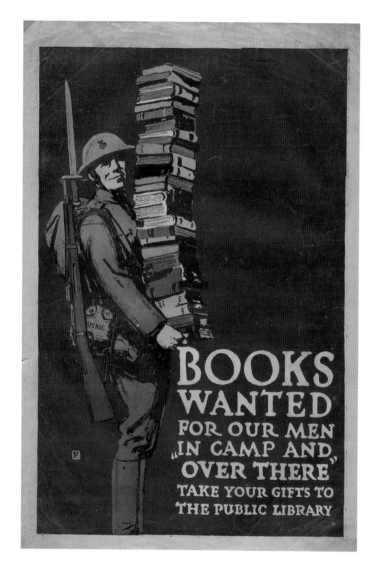

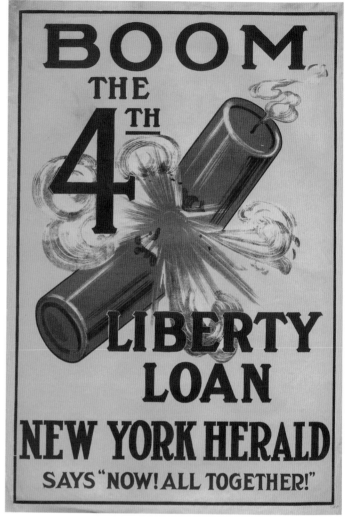

Books Wanted

Lithograph
40 × 29 inches
Collection of the San Antonio
Public Library

BOOM: The 4th Liberty Loan

Lithograph
41 × 28 inches
Collection of the San Antonio
Public Library

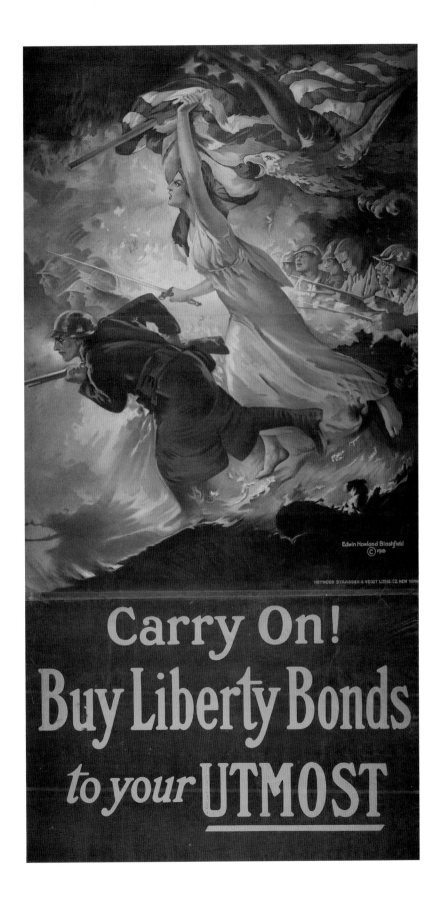

Edward Howland Bloschfield
Carry On! Buy Liberty Bonds to your UTMOST, 1918
Lithograph
96 × 48 inches
Collection of the San Antonio
Public Library

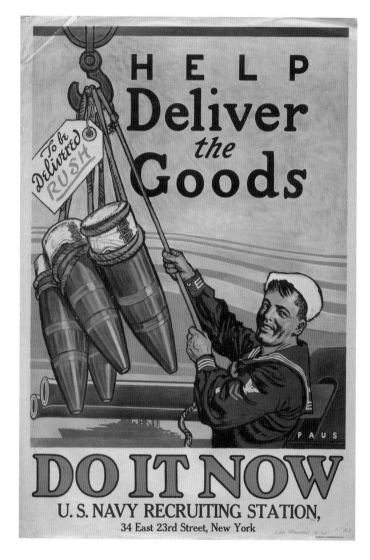

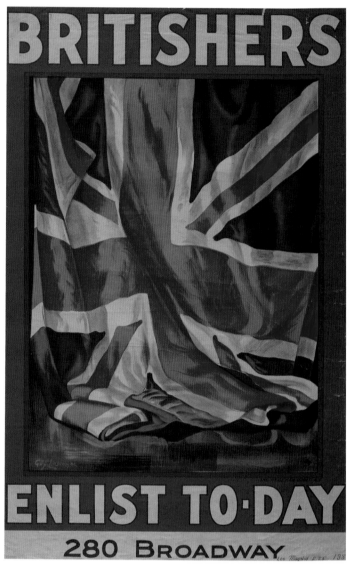

Help Deliver the Goods

Lithograph
41 × 26 inches
Collection of the San Antonio
Public Library

Guy Lipscombe
Britishers ENLIST TO-DAY

Lithograph
41 × 26 inches
Collection of the San Antonio
Public Library

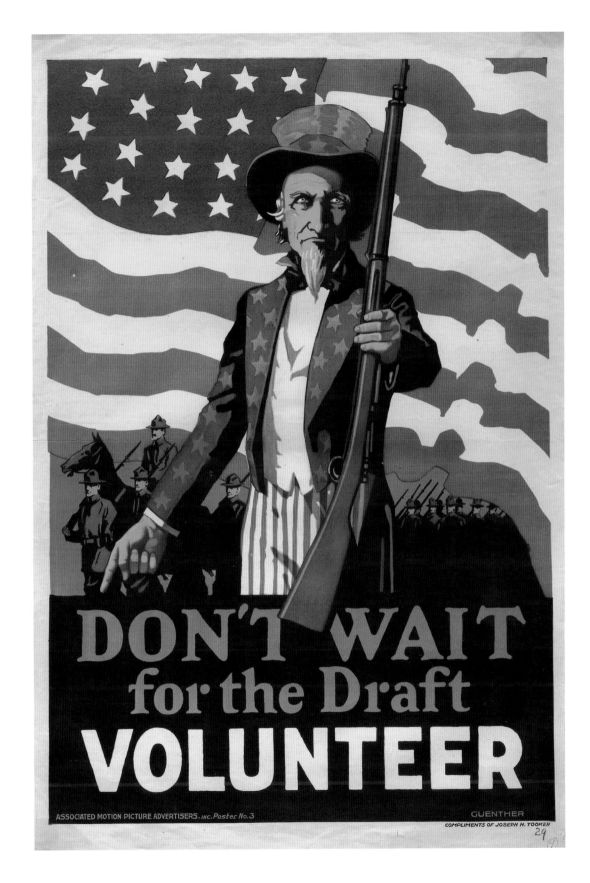

**DON'T WAIT for the Draft
VOLUNTEER**

Lithograph
40 × 28 inches
Collection of the San Antonio
Public Library

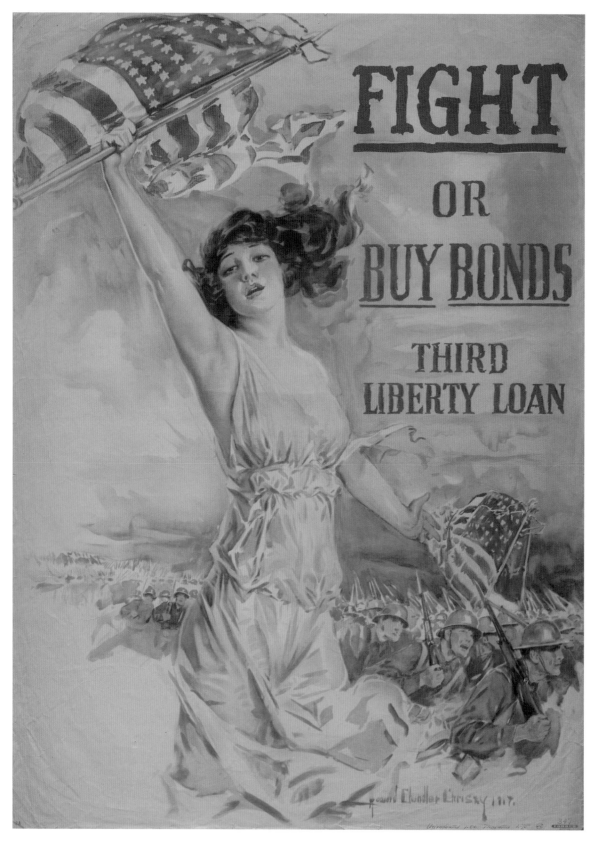

Howard Chandler Christy
FIGHT or Buy Bonds: Third
Liberty Loan, 1917

Lithograph
29 × 19½ inches
Collection of the
San Antonio Public
Library

Howard Chandler Christy
**GEE!! I Wish I Were A Man
I'd Join The NAVY, 1918**

Lithograph
40½ × 26¼ inches
Collection of the San Antonio
Public Library

Howard Chandler Christy (1873–1952)
was one of the outstanding artists who
supported the war effort with his famous
"Christy Girl" and other nymph-like
creatures. Early in his career he had
accompanied troops to Cuba to cover
the Spanish American War as an illus-
trator and journalist for *Scribner's* and
Leslie Weekly. His 1934 murals in the
restaurant Café des Artistes in New
York City remain a New York City art
treasure.

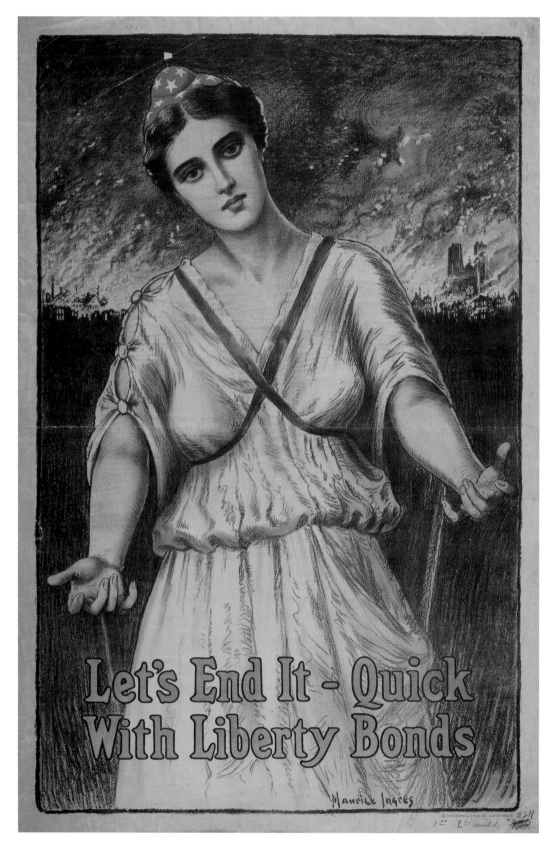

Maurice Ingres
**Let's End It — Quick
With Liberty Bonds**
Lithograph
41 × 28 inches
Collection of the San Antonio
Public Library

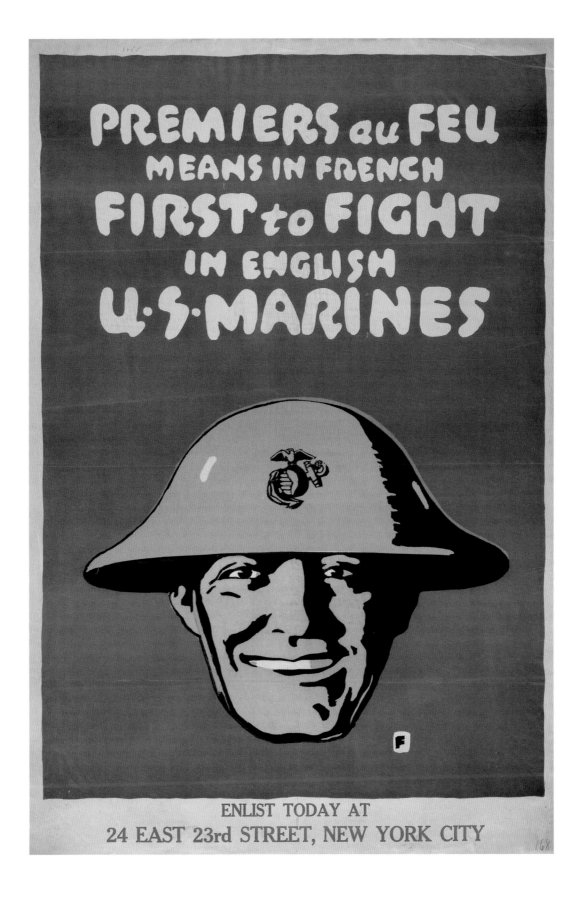

Premiers au Feu Means in French
First to Fight in English
U·S·Marines

Lithograph
43 × 27½ inches
Collection of the San Antonio
Public Library

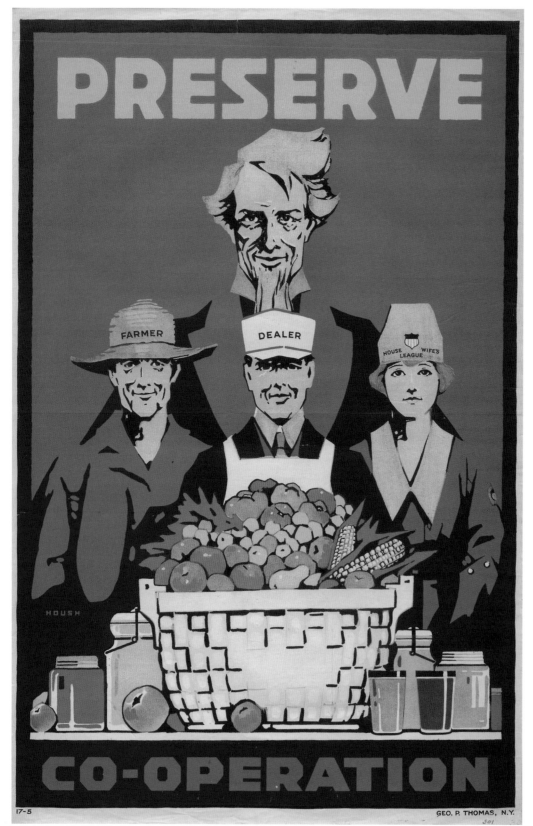

Preserve Co-operation

Lithograph
40 × 27 inches
Collection of the San Antonio
Public Library

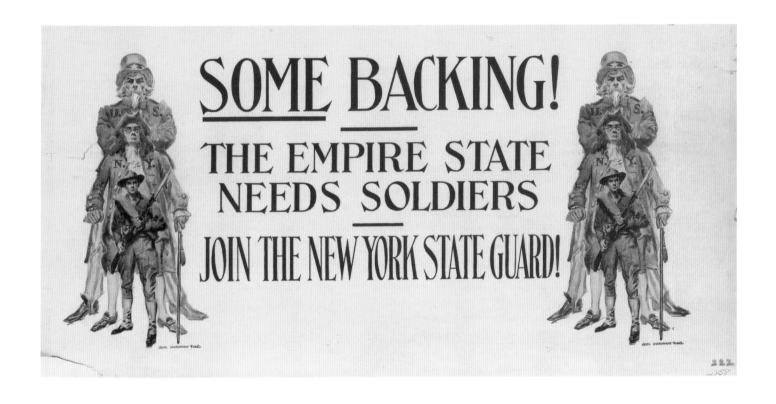

James Montgomery Flagg
Some Backing!
The Empire State Needs Soldiers
Join The New York State Guard!

Lithograph
10¾ × 21¾ inches
Collection of the San Antonio
Public Library

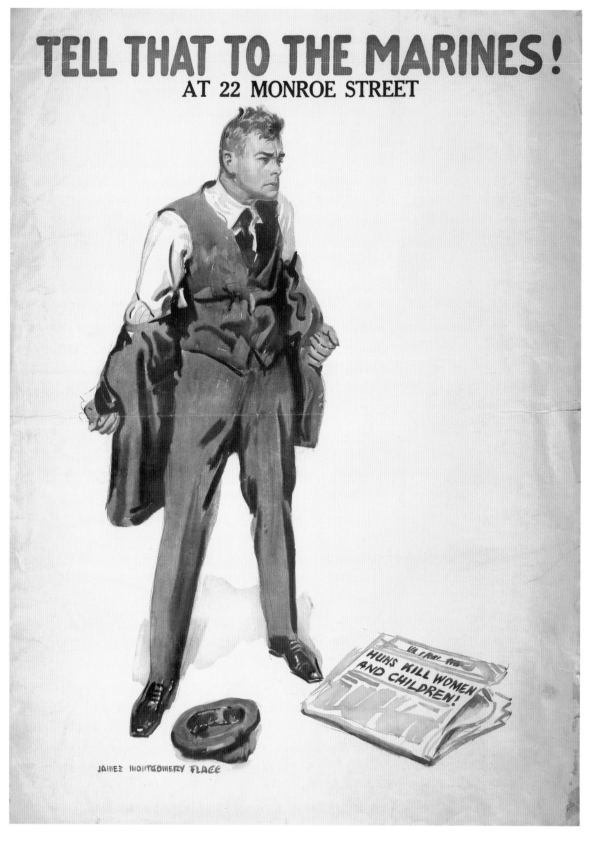

James Montgomery Flagg
TELL THAT TO THE MARINES!

Lithograph
40 × 30½ inches
Collection of the San
Antonio Public Library

James Montgomery Flagg
(1877–1960) was one
of many artists who
painted from a live
model outside, in New
York City, as part of a
publicity campaign on
behalf of the war effort
and Committee of Pub-
lic Information. Flagg
made a clay sculpture
of the same subject.

James Montgomery Flagg
The Spirit of the Red Cross

Lithograph
40 × 27 inches
Collection of the San Antonio
Public Library

W.G. Sesser
They Fight for You
Protect Them

Lithograph
41 × 28 inches
Collection of the San Antonio
Public Library

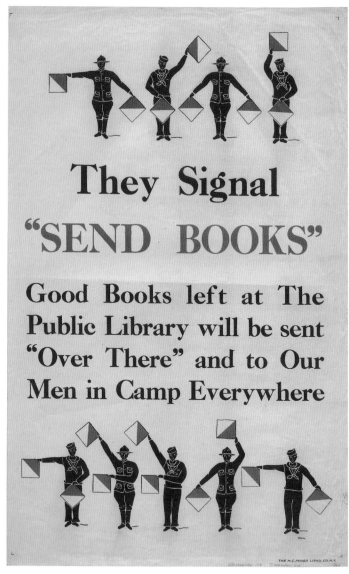

They Shall Not Perish

Lithograph
41 × 28 inches
Collection of the San Antonio
Public Library

They Signal "SEND BOOKS"

Lithograph
37½ × 24 inches
Collection of the San Antonio
Public Library

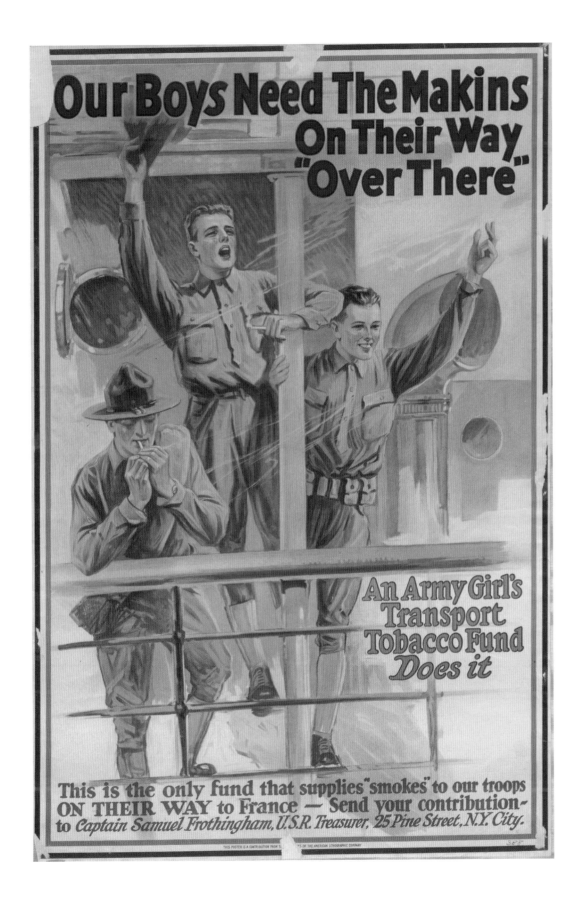

Our Boys Need The Makins
On Their Way "Over There"

Lithograph
30 × 20 inches
Collection of the San Antonio
Public Library

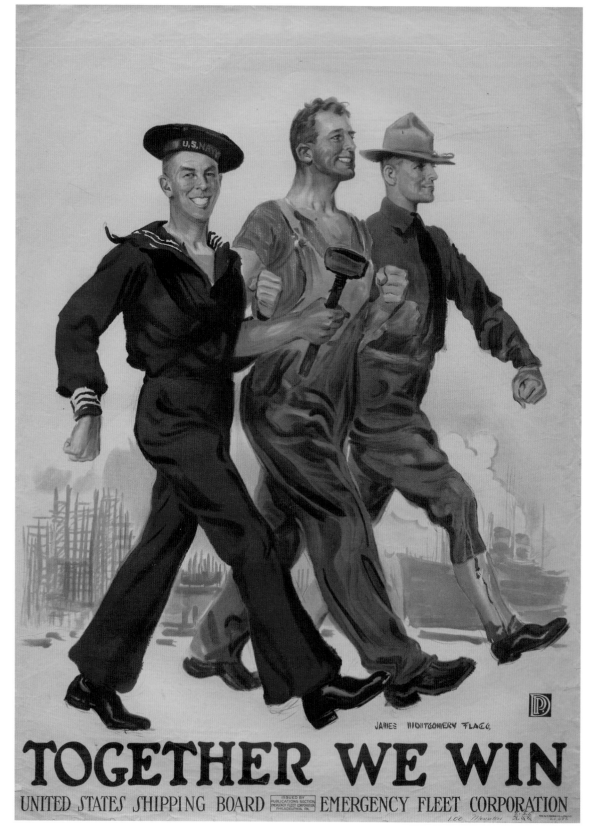

James Montgomery Flagg
TOGETHER WE WIN

Lithograph
39 × 29 inches
Collection of the
San Antonio Public Library

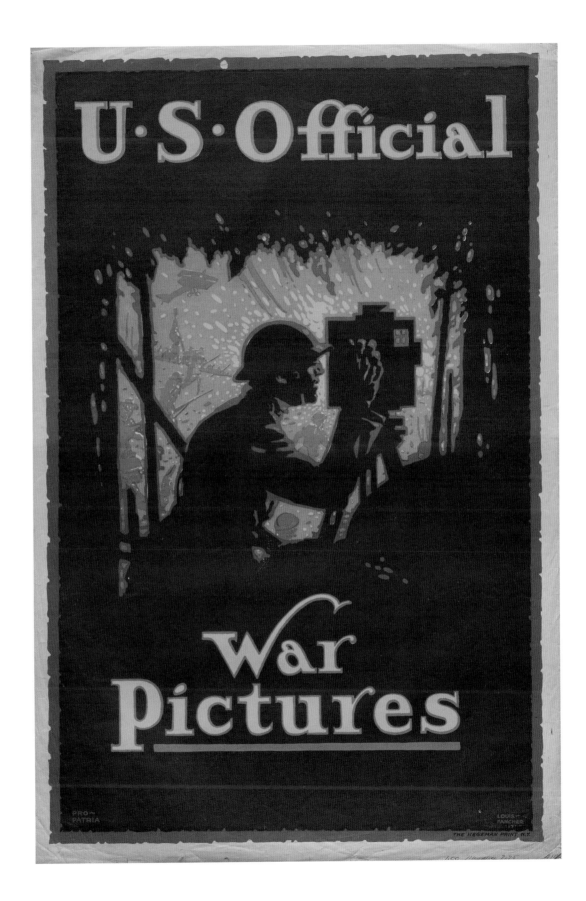

U·S·Official War Pictures

Lithograph
41 × 28 inches
Collection of the San Antonio
Public Library

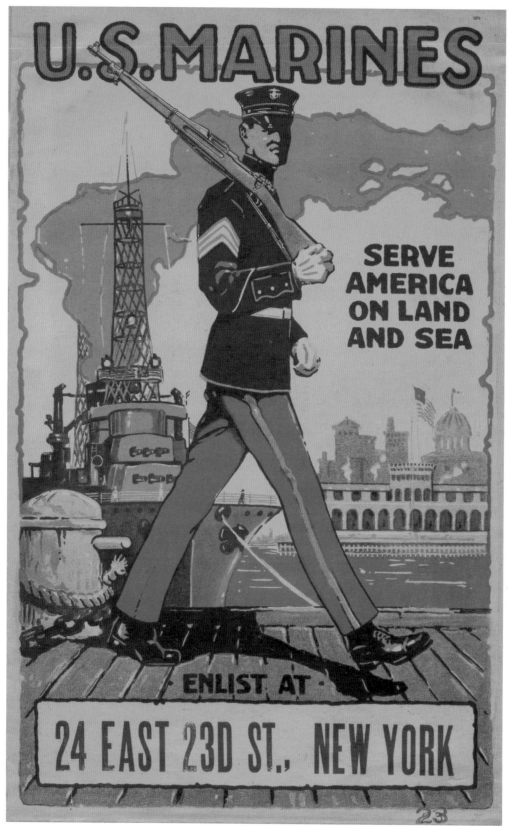

**U.S. MARINES SERVE AMERICA
ON LAND AND SEA**

Lithograph
21¾ × 13¾ inches
Collection of the San Antonio
Public Library

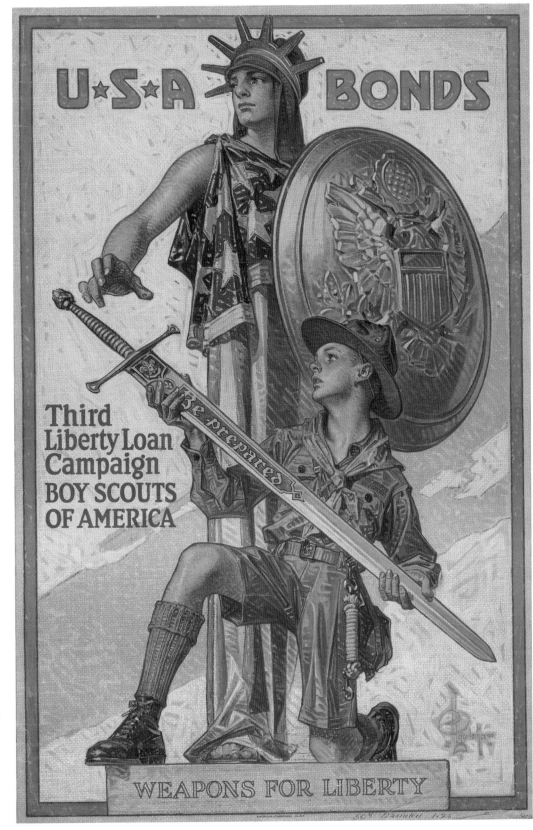

Joseph C. Leyendecker
U∗S∗A BONDS
Third Liberty Loan Campaign

Lithograph
29¾ × 19¾ inches
Collection of the San Antonio
Public Library

Joseph C. Leyendecker (1874–1951)
immigrated from Germany at age
eight and with his younger brother,
Frank, pursued a career in art. Study-
ing at the Chicago Art Institute,
Leyendecker later went on to study
at the Académie Julian in Paris. His
training served him well as a commer-
cial illustrator; he landed his first
cover for *The Saturday Evening Post*
in 1899. During the next forty years,
Leyendecker went on to create more
than 300 covers for the magazine
and with his elegant style became
highly successful as an advertising
illustrator.

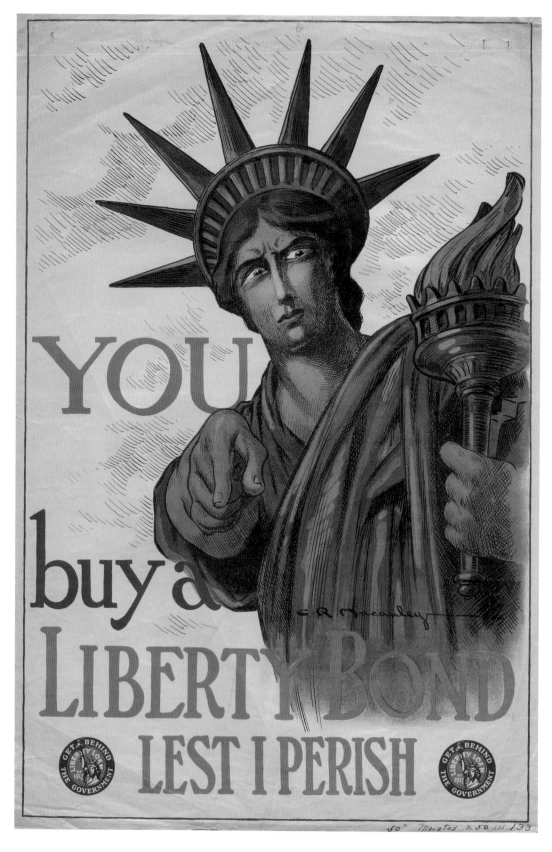

You buy a Liberty Bond
Lest I Perish

Lithograph
30¾ × 20 inches
Collection of the San Antonio
Public Library

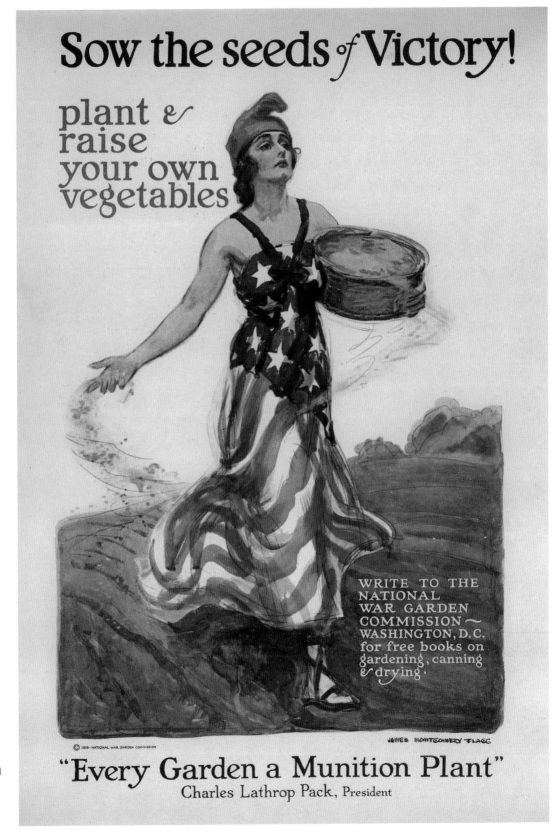

James Montgomery Flagg
Sow the seeds of Victory!

Lithograph
12 × 9 inches
Collection of the San Antonio
Public Library

James Montgomery Flagg (1877–1960) was one of the most memorable of the official military artists hired to promote the war. Flagg was also one of the most prolific, producing over 45 poster images. The Victory Garden theme was so successful it would be revived during World War II. The model for this version of Lady Liberty was Isle Hoffmann, Flagg's longtime companion.

SELECTED BIBLIOGRAPHY

American Art Annual. Washington, D.C.: American Federation of Arts, 1898–1936.

American Art by American Artists. New York: P. F. Collier & Son, 1914.

Busby, Brian John. *In Flanders Field: And Other Poems of the First World War.* New York: Arcturus Books, 2005.

Creel, George. *How We Advertised America.* 1920. Reprint, New York: Arno Press, 1972.

Cummings, E. E. *E. E. Cummings: Complete Poems 1904–1962.* Edited by George James Firmage, New York: Liveright, 1994.

Dos Passos, John. *Three Soldiers.* 1921. Reprint, New York: Penguin, 1997.

Downey, Fairfax. *Portrait of an Era as Drawn by C. D. Gibson.* New York and London: Charles Scribner's Sons, 1938.

Eliot, T. S. *Collected Poems, 1909–1962.* The Centenary Edition. New York: Harcourt Brace Jovanovich, 1991.

Faulkner, William. *As I Lay Dying.* New York: Random House, 1930.

———. *Soldiers' Pay.* New York: Random House, 1926.

Fussell, Paul. *The Great War and Modern Memory.* New York: Oxford University Press, 2000.

Gallatin, Albert Eugene. *Art and the Great War.* New York: E. P. Dutton & Co., 1919.

The Gibson Book. A Collection of the published works of Charles Dana Gibson in two volumes. New York: Charles Scribner's Sons, R. H. Russell, 1907.

Hemingway, Ernest. *A Farewell to Arms.* New York: Scribner's, 1929.

———. *The Sun Also Rises.* New York: Scribner, 1926.

A History of Military Aviation in San Antonio. Private publication by Air Force historians, September 1996.

Kennedy, David M. *Over Here: The First World War and American Society.* New York: Oxford University Press, 2004.

Link, Arthur S. *Wilson the Diplomatist: A Look at His Major Foreign Policies.* Baltimore: Johns Hopkins Press, 1957.

———. *Woodrow Wilson: Revolution, War, and Peace.* Arlington Heights, Ill.: H. Davidson, 1979.

———. *Wilson.* Princeton, N.J.: Princeton University Press. Vol. I: "The Road to the White House," 1947; Vol. II: "The New Freedom," 1956; Vol. III: "The Struggle for Neutrality, 1914–1915," 1960; Vol. IV: "Confusions and Crises, 1915–1916," 1964; Vol. V: "Campaigns for Progressivism and Peace, 1916–1917," 1965.

Meyer, Susan. *James Montgomery Flagg.* New York: Watson-Guptill Publications, 1974.

Mock, James R., and Cedric Larson. *Words That Won the War: The Story of the Committee on Public Information, 1917–1919.* 1939. Reprint, New York: Russell & Russell, 1968.

Owen, Wilfred. *The Collected Poems of Wilfred Owen.* New York: New Directions, 1965.

Persico, Joseph E. *Eleventh Month, Eleventh Day, Eleventh Hour: Armistice Day, 1918, World War I and Its Violent Climax.* New York: Random House, 2005.

Reed, Walt. *The Illustrator in America 1900–1960s.* New York: Reinhold Publishing, 1966.

Remarque, Erich Maria. *All Quiet on the Western Front.* Boston, 1929.

Sassoon, Siegfried. *The War Poems of Siegfried Sassoon.* Edited by Rupert Hart-Davis. New York: Bibliobazaar, 2007. First published 1983 by Faber and Faber, London.

Tuchman, Barbara W. *The Guns of August.* Presidio Press, 1962.